IMAGES
of America

PERRIS VALLEY

CALIFORNIA SOUTHERN RAILROAD, 1890s. Railroad history is one of the most significant aspects of American history. Perris is one city that was born into that history; the railroad was and still is an integral part of the city. (Courtesy of the Perris Valley Historical Museum.)

ON THE COVER: HOOK BROS. & OAK, PERRIS VALLEY SUPPLY CO. Coming from San Francisco and looking to start a business in a warmer climate, brothers Albert and Joseph Hook and their partner Ira Oak established one of the busiest and most successful businesses in Perris. They sold items needed for farming, gold mining, and family needs. It was located on the southwest corner of D and Seventh Streets. The building is no longer standing. (Courtesy of Perris Valley Historical Museum.)

# IMAGES of America
# PERRIS VALLEY

The Perris Valley Historical & Museum Association

Copyright © 2016 by The Perris Valley Historical & Museum Association
ISBN 978-1-4671-1687-9

Published by Arcadia Publishing
Charleston, South Carolina

Printed in the United States of America

Library of Congress Control Number: 2016944063

For all general information, please contact Arcadia Publishing:
Telephone 843-853-2070
Fax 843-853-0044
E-mail sales@arcadiapublishing.com
For customer service and orders:
Toll-Free 1-888-313-2665

Visit us on the Internet at www.arcadiapublishing.com

*Dedicated to Marion Ashley, Riverside County supervisor,
Fifth District, who has devoted a large part of his life to making
Perris Valley a better place to live. Thank you, Marion.*

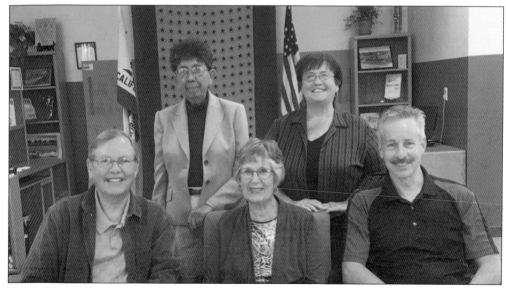

PERRIS VALLEY HISTORICAL MUSEUM VOLUNTEERS. Pictured are, from left to right, (first row) Bill Hulstrom, Midgie Parker, and Dan Yost; (second row) Mae Minnich and author Katie Keyes.

# Contents

| | | |
|---|---|---|
| Acknowledgments | | 6 |
| Introduction | | 7 |
| 1. | The Early Years | 9 |
| 2. | Legacy of Farming and Water | 59 |
| 3. | Pioneering Families | 77 |
| 4. | The Mid-Century | 91 |
| 5. | Modern Times | 113 |

# Acknowledgments

History is a fascinating part of our universe, and my love of local history is what prompted me to write this book and share what has captivated my interest for so many years. After living in this wonderful valley all 73 years of my life, my main focus is to show you, through images and captions, a story of what the people of Perris Valley were like and what they did for more than 130 years.

To the many people who contributed photographs to tell the story of Perris Valley, I sincerely thank you for helping make this book complete. You have been acknowledged in the captions for the photographs you provided. Unless otherwise noted, all photographs are courtesy of the Perris Valley Museum Historical Archives.

Thank you to the volunteers at the Perris Valley Historical & Museum Association who helped locate photographs for the book: Bill Hulstrom, Mae Minnich, and Midgie Parker. Special thanks to Dan Yost for his many hours spent assembling all the photographs.

Enjoy learning about the rich history of the Perris Valley.

—Katie Keyes
on behalf of the Perris Valley Historical Museum

# INTRODUCTION

From prehistoric times, Indians inhabited the land known as the San Jacinto Plains, named for the river that crosses it. Their trails crisscrossed the valley until Spanish and Mexican miners found gold deposits in the hills. Sheep roamed the valley, and more people began to notice what Perris Valley had to offer: a moderate climate, rich and fertile soil, and plenty of land.

In 1881, the California Southern Railroad decided to lay its tracks through Perris Valley. Frederick Thomas Perris, chief engineer and superintendent of construction for the railroad, was in charge of the route. In 1882, the tracks were completed.

In the town of Pinacate, a post office, a few businesses, and a depot made from a boxcar were established. The Orange Empire Railway Museum is now located on the site. Settlers came to homestead and purchase property, and Pinacate was reported to have a population of 400 people at one time. Within a short time, land disputes erupted that caused Pinacate's demise.

In 1885, people to the north discussed the idea of a more conveniently located town. Contacting railroad magnates and businesspeople in San Bernardino, Fred Perris returned to the valley to study a new proposal. It included the creation of a well and the donation of a number of lots to the railroad in exchange for erecting a train depot. Because of the support for the project from Fred Perris, Jas. E. Mack from San Bernardino, the railroad, and the people from the area named the town in honor of him.

The townsite of Perris officially became a station on the Transcontinental Route of the Santa Fe Railroad on April 1, 1886, and by 1887, six passenger trains and two freight trains were stopping at Perris daily. In the early 1890s, the Temecula gorge washed out from repeated storms, and the railroad decided to discontinue service to San Diego.

On May 26, 1911, Perris became an incorporated city. Agriculture was the driving force of the valley's economy, with the city being the business center for supplies and commerce. The main crops were dry grain farming, alfalfa, and potatoes. The Perris Valley became famous for the White Rose variety of potatoes. Other crops were onions, sugar beets, and melons, among many other varieties of fruits and vegetables. By the 1980s, farming had waned due to the high cost of irrigation water and an unreliable market.

Over the years, many attractions have come to the Perris area: the Orange Empire Railway Museum, Skydive Perris (an internationally renowned paracenter), Lake Perris State Recreation Area, Southern California Fair, Perris Auto Speedway, Perris Valley Historical Museum, Dora Nelson African American Art & History Museum, Drop Zone Water Park, and Big League Dreams.

Over the past decade, the city has restored and improved many historic and downtown buildings. Today, Perris Valley is a diversified and multicultural area with a mix of housing, industrial, and job-producing businesses.

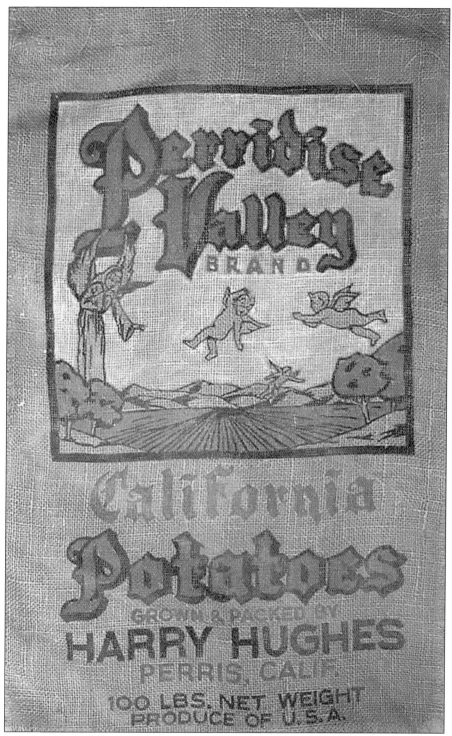

**HARRY HUGHES & SON POTATO SACK WITH PERRIDISE BRAND.** Most of the potato farmers in Perris Valley had a potato sack that included a brand. The one pictured was used by Harry Hughes and his son Norman when they farmed in the 1930s through the 1960s.

# One

# The Early Years

**Frederick Thomas Perris.** As chief engineer of the California Southern Railroad, Fred Perris was asked to look into building a new railroad depot in the Perris area. He traveled from San Bernardino to check out the location and report back to Jas. E. Mack and other businessmen. Perris informed them it was a positive, workable plan and was instrumental in building the beautiful Victorian brick depot in Perris. Fred Perris's son-in-law Benjamin Franklin Levet was the architect of the depot. Levet was also the architect for other California depots. Mack and others were grateful to Fred Perris and named the town in his honor.

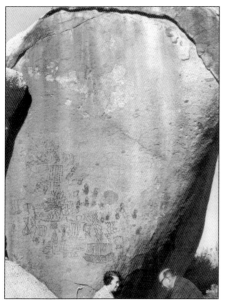

INDIAN PICTOGRAPH. This pictograph is located at the Motte Rimrock Reserve in the rocky western edge of Perris, formerly known as the Penny Ranch. Charles Motte and his wife, Ottie, purchased the property in the 1950s and, over the next few years, donated hundreds of acres to the University of California Reserve System. Other property owners, including the Schlundts and Dr. Ann Parker, also donated small amounts of land. The pictograph shows a painting done by Native American girls in a puberty ritual. The reserve is one of the finest of its kind in the western United States. In the photograph are Mrs. Penny and Dr. Gerald Smith, founder of the San Bernardino County Museum. (Courtesy of the San Bernardino County Museum.)

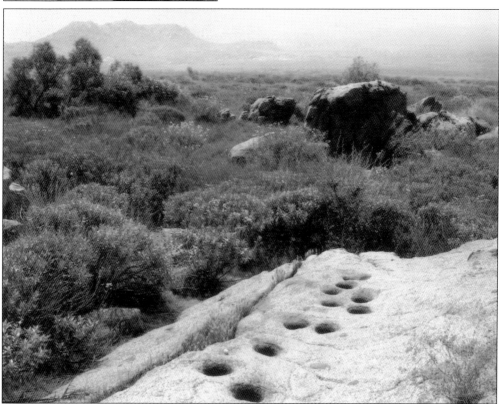

BEDROCK MORTAR MILLING STATION. Found in the Perris area, these features were used by the Native American women to grind seeds, acorns, and other grains into food. The very large rocks had several mortar-type holes in them and were used with a pestle by the women who would gather there to socialize and discuss village concerns. The milling station would be passed down through the family to the next generation.

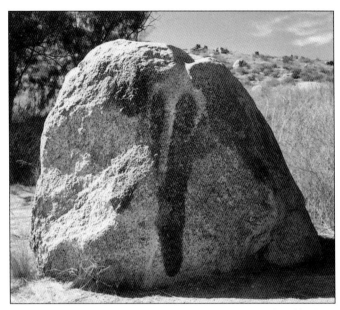

PETROGLYPH BY LAKE PERRIS. This petroglyph is found on the southern end of Lake Perris's rocky slopes north of the Ramona Expressway. Petroglyphs are made by pecking and grinding into the stone. This petroglyph is a fertility symbol and helps tell the Indian creation story of Mother Earth and Father Sky. A few different Native American tribes inhabited Perris Valley over the last 800 years, mainly the Luiseño, who were named by the Spanish from San Luis Rey Mission. (Courtesy of Paul J. Price.)

PERRIS INDIAN SCHOOL. In September 1890, commissioner of Indian affairs Thomas J. Morgan instructed US Indian agent Horatio N. Rust to select a suitable site for a training school located away from any reservation in a settlement that had already been established. An 80-acre site on the northeast corner of Perris Boulevard and Morgan Street was purchased and buildings were erected. It was used as an Indian training school from 1890 to 1904, when a new school opened in Riverside as the Sherman Indian School.

PINACATE ROCK HOUSE DUGOUT. Pinacate was a small town located 1.7 miles south of downtown Perris. It was also known for the Pinacate Mining District established in 1878 with the discovery of gold throughout the valley. The Pinacate dugout housed a post office and small store. Property disputes broke out and caused the demise of the town. On November 15, 1980, it was designated as a California Point of Historical Interest. The Orange Empire Railroad Museum is located at this site today.

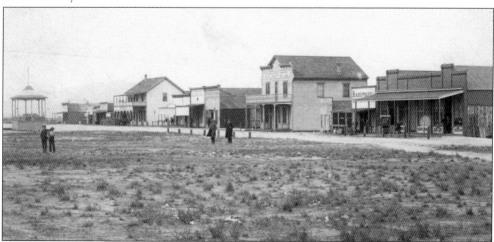

DOWNTOWN PERRIS, 1893. This early photograph of downtown D Street in Perris shows the Southern Hotel, which is still standing today, along with other historic buildings. The gazebo in the street was a community gathering place. (Courtesy of the Leonard Kirkpatrick Jr. family.)

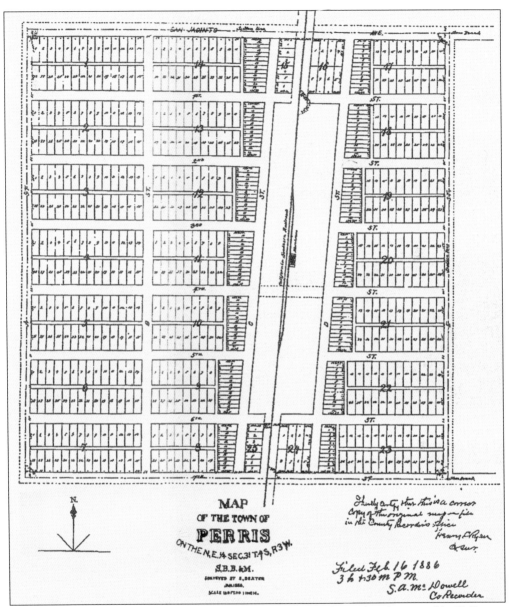

**SURVEY MAP OF PERRIS.** The 160-acre townsite of Perris was planned and surveyed by E. Dexter in late 1895 and early 1896. Most of the original street names are still used today. The town was bounded by San Jacinto Avenue on the north, Seventh Street on the south, A Street on the west, and E Street (now known as Perris Boulevard) on the east.

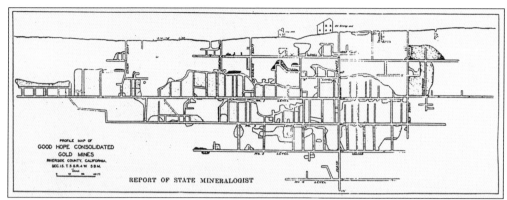

GOOD HOPE CONSOLIDATED GOLD MINE. This map shows the seven-level labyrinth of tunnels. The mine is now full of water and has been closed due to safety reasons for several decades. The mine, located along the west side of State Highway 74 near River Road between Perris and Lake Elsinore, is no longer visible from the road.

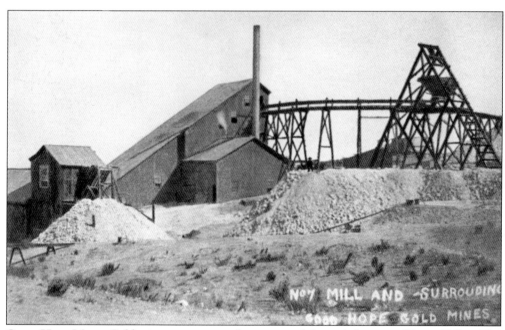

GOOD HOPE MINE. Gold mining was a significant part of the early history of Perris Valley. The Good Hope Mine was the largest of the many gold mines found in this area. Located west of Perris, it is known to be the largest gold-producing mine in Southern California. Its history was passed down by the Doroteo Trujillo family, who lived in Perris and might have discovered its gold. A multitude of owners have worked the mine over the years.

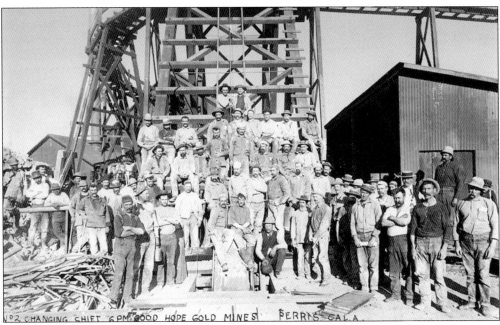

**GOOD HOPE MINE CREW CHANGING SHIFTS.** These hardworking Good Hope gold miners are shown at the end of their shift. When they entered the mine, they were given a candle that would be broken in half and dug into the mine wall with the sharp end of an iron candleholder. Once the first half of the candle had burned down, they would take a break for lunch; when the second half burned down, their shift was over for the day.

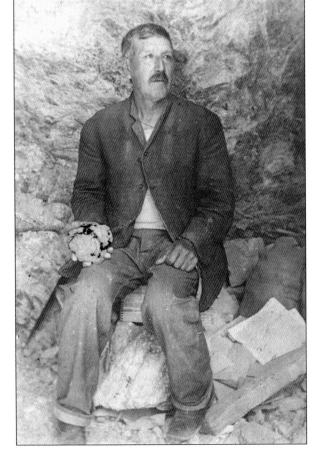

**DARIO TRUJILLO.** Dario is the son of Doroteo Trujillo, one of the early gold miners in the area who is purported to have discovered the Good Hope Gold Mine. He is shown holding a large piece of quartz rock with gold entwined in it. Dario and his wife, Sarah, lived in Perris with their seven children and continued to mine for gold.

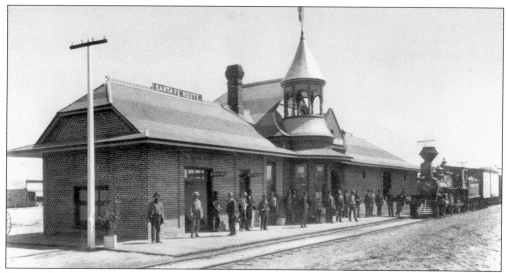

**PERRIS SANTA FE DEPOT.** The grand opening for one of the most beautiful Victorian redbrick railroad depots built in California was held on March 16, 1892. The passengers and Perris citizens alike enjoyed the festivities. Benjamin Franklin Levet was the architect for the depot. He was the son-in-law of Frederick T. Perris, the chief engineer of the California Southern Railroad and the namesake of Perris. Fred Perris was chiefly responsible for having this depot built in Perris.

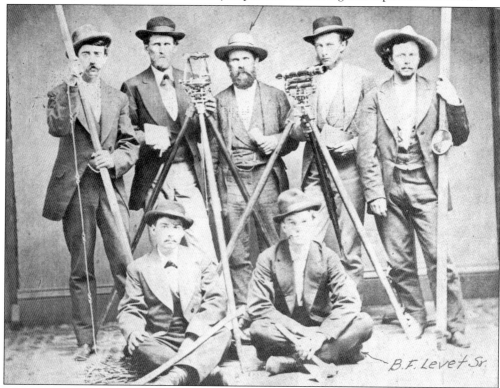

**FRED PERRIS SURVEY CREW.** Shown in this interesting photograph is the survey crew of Fred Perris when they were working on the Transcontinental Railroad route. Fred Perris is standing in the middle of his crew, and Benjamin Franklin Levet is seated on the right.

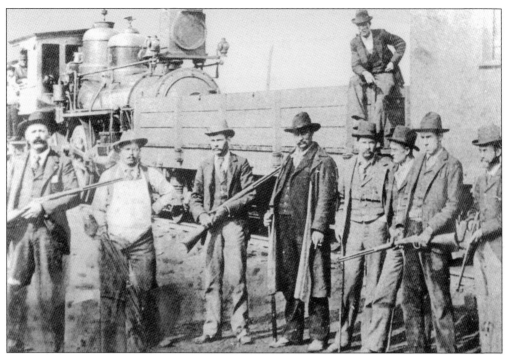

FRED PERRIS WITH WYATT EARP. The true origin of this photograph is unknown, but one theory suggests that is was posed with Fred Perris's gun collection. From left to right are Virgil Earp, James Earp, Benjamin Franklin Levet, Wyatt Earp, Newton Earp, unidentified, Warren Earp, Fred Perris, and an unidentified man on the flatcar. The gun Levet is shown holding is now on display at the Perris Valley Historical Museum.

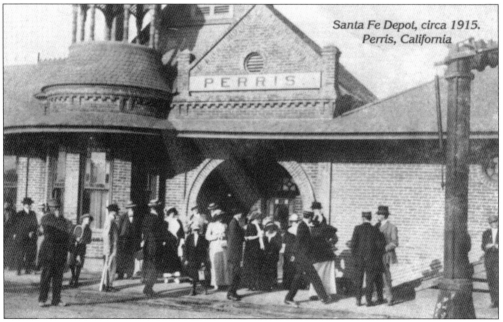

PERRIS DEPOT CROWD. Both men and women are shown waiting for a train at the Perris depot in 1915. It is interesting to see the crowd and the clothing of the times.

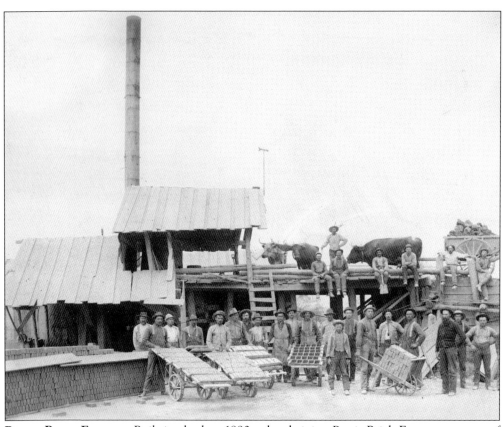

PERRIS BRICK FACTORY. Built in the late 1880s, the thriving Perris Brick Factory was one of the first industries in Perris. According to a story in the holiday supplement to the *New Era* on January 1, 1891, they were in the process of filling a contract for one million bricks for the Bear Valley Irrigation Co. Several buildings in Perris were made with bricks from the factory, including the Perris Santa Fe depot, the two-story Perris Grammar School, the Perris Indian School, and several downtown Perris buildings. This photograph of the factory, located on the southeast corner of Perris Boulevard and First Street, was taken in 1887. (Courtesy of the Vera Akin Xydias Collection, Perris Valley Museum Historical Archives.)

MAPES GROCERY STORE. Maynard Mapes and his wife, Iona, purchased a general store from J.W. McCanna in a prime location on the southeast corner of D and Fourth Streets. The Mapes family also farmed in the valley, and Maynard delivered the mail on horseback after picking it up from the Perris depot. The postmaster general appointed Maynard as the Perris postmaster on March 29, 1889.

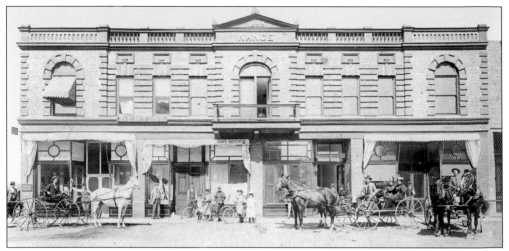

NANCE BUILDING. Built by J.W. Nance in 1895, this building was one of the most attractive of its day in Perris. It was located west of D Street, just north of Fourth Street. Several businesses were located in this building, including the Perris Post Office. Unfortunately, the building burned down in 1905 and was replaced by a grain storage facility used by Colton Grain and Milling and others for many years.

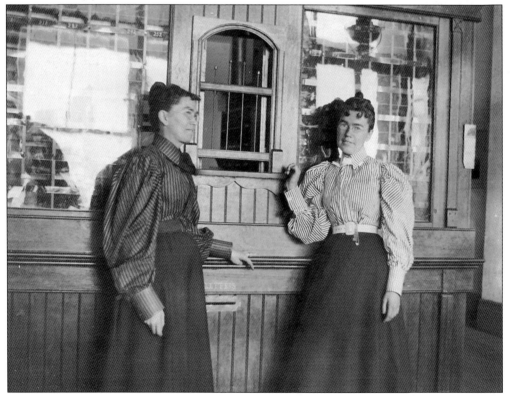

PERRIS POSTMISTRESS. The Perris Post Office was located in the newly constructed Nance building. This photograph shows Postmistress Whitney (left) and her sister working there. Having a female postmistress indicates that the government was an equal opportunity employer even in 1895. The Nance building interior looks like it was beautifully decorated with solid-wood cabinetry.

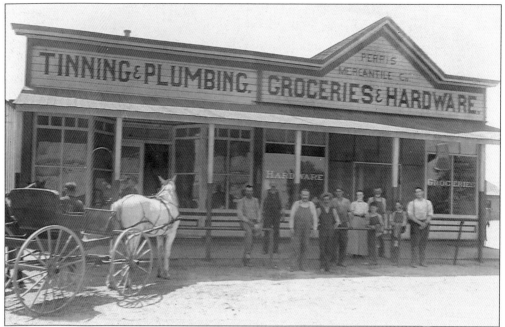

**PERRIS MERCANTILE COMPANY.** This building was located southwest of D and Fourth Streets. The company sold groceries, provisions, hardware, and other necessities. They worked with sheet metal, copper, and tin and specialized in tank houses. One of the things the Perris Valley Museum found in its archives was a decorator plate featuring the Perris Mercantile Co., along with roses and a 1911 calendar. A picture of it was used on the 2011 centennial calendar made by the museum, and the City of Perris copied the plate and updated the calendar to 2011 to serve as a souvenir.

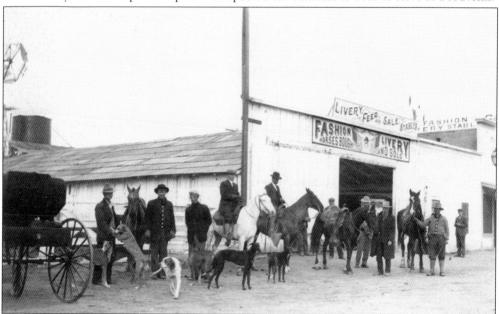

**FASHION LIVERY STABLE.** George Braum owned the Fashion Livery of Perris, one of the best county stables. Braum had several head of horses and prided himself on his up-to-date equipment and reasonable rates. He was very accommodating to the residents of Perris Valley and visitors.

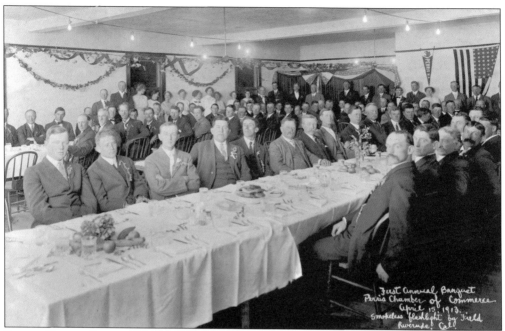

PERRIS VALLEY CHAMBER OF COMMERCE. The chamber of commerce held its first installation dinner on April 15, 1913. After the City of Perris incorporated in 1911, the business community established a chamber of commerce. This impressive photograph shows the strength of the organization. Benjamin Franklin Levet, the architect of the Perris depot, is at far left in the first row, and Henry Akin is sixth from left in the second row.

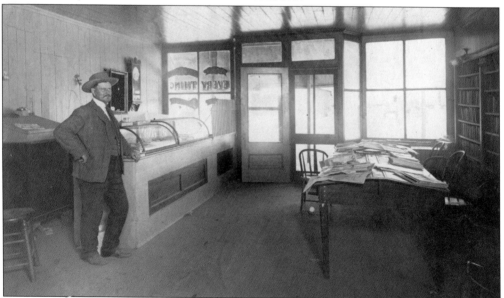

HENRY AKIN LIBRARY. After moving his family from their farm in the Menifee area to Perris in 1891, Henry Akin decided to open a library in conjunction with a bicycle repair shop and jewelry store in 1901. His wife, Martha "Mattie" Akin, was an avid reader and wrote for the newspaper, thus she likely had an influence in starting a library. This was the first library established in Riverside County. From 1912 to 1914, Henry served as city clerk in Perris after it incorporated.

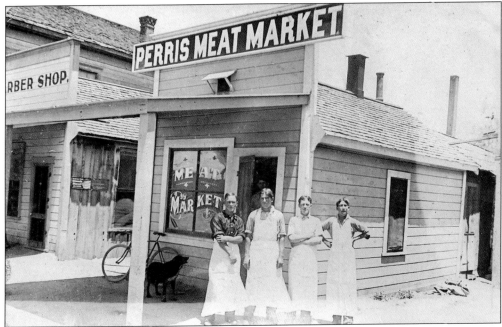

PERRIS MEAT MARKET. Like many others seeking relief for their health, Myron Wolcott came to Perris because of his asthma. After arriving in Perris he became involved in a butcher business with Maynard Mapes. Wolcott bought Mapes out and expanded his business to include deliveries as far away as 30 miles out of town. These people are unidentified but look to be a hardy crew.

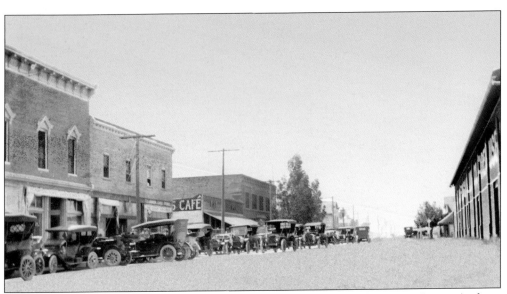

D STREET LOOKING SOUTH. This c. 1917 street scene shows a busy downtown Perris. At front left is the Evelyn Hall building. The lower floor was used for businesses and upstairs was used for meetings for the chamber of commerce, the Masons, DeMolay, and Job's Daughters, among others. It was used for dances, dinners, and even high school classrooms in 1932 after a portion of the high school burned down. On the right side of the street is the Colton Grain & Milling building.

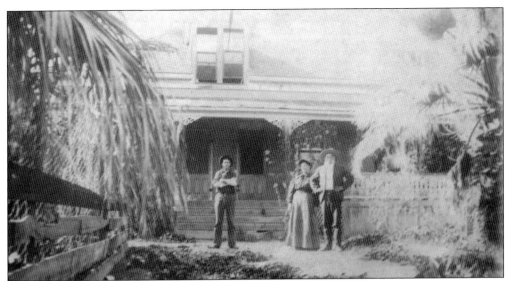

BERNASCONI HOT SPRINGS HOUSE. One of the earliest settlers in Perris Valley was Swiss immigrant Bernardo Bernasconi. Arriving in 1878, he tended sheep and cattle on his property in the Lakeview area. He amassed more than 300 acres and had a small adobe dwelling. While traveling to San Francisco in 1883, he met and married Marcellina Orso, also from Switzerland. She was a governess for the Swiss consulate. Bernardo had promised her a house to live in when they got married, but when arriving at the property, she found a small adobe and no bed. She had to make a bed out of sheepskins. She went to live at the Pico Rancho down the road until her husband built a beautiful house on the Bernasconi Hot Springs property. (Courtesy of John Motte.)

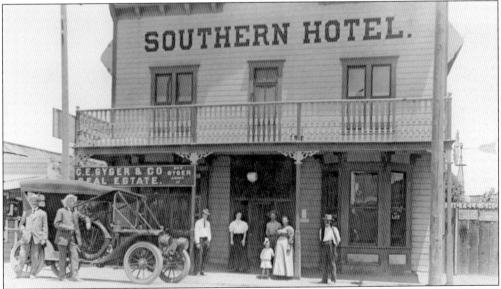

SOUTHERN HOTEL. At the urging of his wife, Bernardo Bernasconi built the Southern Hotel in 1886. The 24-room, two-story hotel was located at 445 D Street in Perris. It was one of the first commercial buildings in early Perris. It catered to visitors arriving on the train and to gold miners working in the area. After almost being destroyed by several fires, it was beautifully restored by the John Motte family in 1990 and was listed in the National Register of Historic Places in 1992. (Courtesy of the Ben Minnich Collection, Perris Valley Museum Historical Archives.)

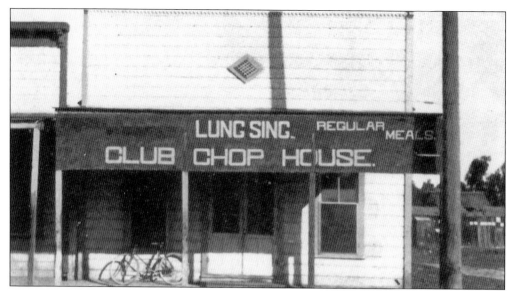

LUNG SING CLUB CHOP HOUSE. In the late 1890s and into the early 1900s, the chophouse was known as one of the best restaurants in Perris. Chinese-born Lung Sing faithfully served his patrons with a happy smile. The cost of having a great meal in his establishment was 25¢.

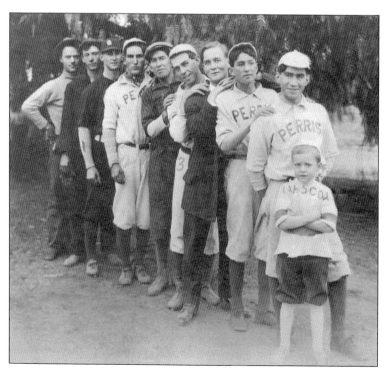

PERRIS BASEBALL TEAM. This c. 1905–1910 photograph shows, from front to back, Jimmy Noonan (mascot), Albert Trujillo, Selio Trujillo, Chester Cutler, Don Knowles, Frank Trujillo, Odie Beam, Elmer Rieger, Peter Pauly, and Ralph Ingraham. Team member Elmer Rieger achieved his dream of becoming a relief pitcher in the major leagues.

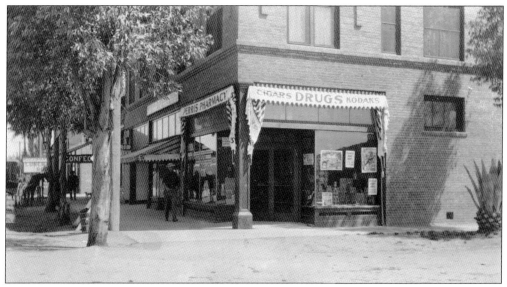

PERRIS DRUGSTORE EXTERIOR. The brick building housing the Perris Drugstore was established after the early wooden Perris Hotel burned down at the turn of the 20th century. It was constructed of bricks from the Perris Brick Factory. The window displays advertisements of the day. The upper floor housed the Poinsettia Hotel and later the Perris Hotel.

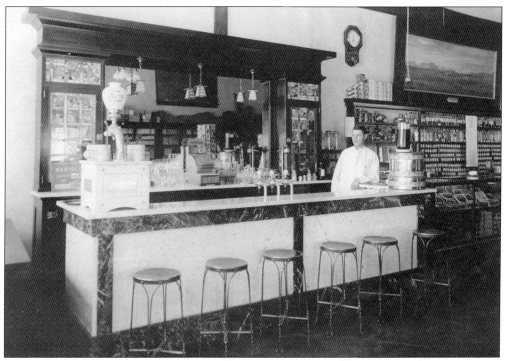

PERRIS DRUGSTORE INTERIOR. The Perris Drugstore was opened by Dr. W.F. Perry, who came to Perris looking for a milder and drier climate for his health. It was located on the northeast corner of Fourth and D Streets in the center of Perris. This photograph taken in 1909 shows clerk Vern Akin behind the soda fountain in a fully stocked store. (Courtesy of the Vera Akin Xydias Collection, Perris Valley Museum Historical Archives.)

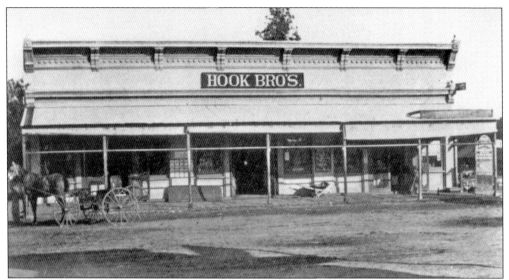

HOOK BROS. DRY GOODS STORE. The Hook brothers built this dry goods store on the southeast corner of Fifth and D Streets in 1904. Having a successful business in their Hook & Oaks Store, they saw a need for other merchandise necessary for Perris Valley residents. The city later used the building for the Perris city hall, police department, volunteer fire department, and library.

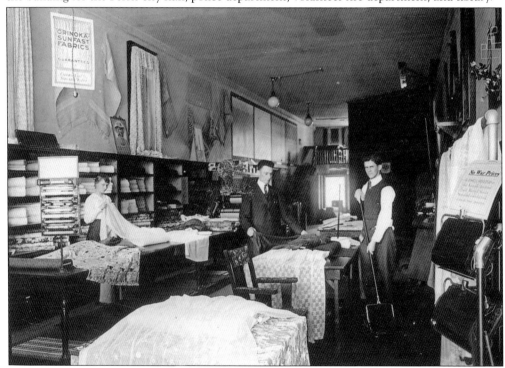

INTERIOR OF HOOK BROS. STORE. Pictured inside the store are three unidentified Hook Bros. employees. These well-dressed attendants are ready to help customers with merchandise. Fabric, lace, tablecloths, and luggage are some of the items shown. The Hook brothers, Albert and Joseph, were well-respected and honest businessmen who worked hard to take care of their customers' needs. The Perris City Council met in a room at the back of this building for many years.

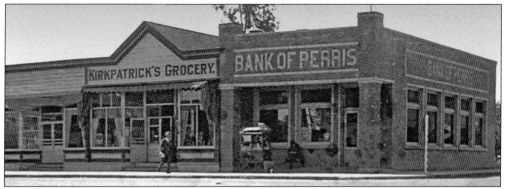

BANK OF PERRIS EXTERIOR. Bank owner Wilbert W. Stewart built this handsome brick building to house the Bank of Perris on the southwest corner of Fourth and D Streets in 1918. Wilbert was a well-respected and honorable gentleman who helped his community in both the good times and the bad times. With farming being the largest industry in the Perris Valley, they depended on Stewart to get them through from year to year. In 2010, the City of Perris restored the building, and it is now used as the Perris Valley Historical Museum's archival facility.

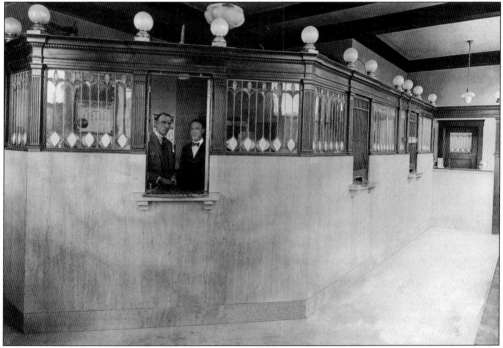

BANK OF PERRIS INTERIOR. Shown inside is an exquisitely decorated bank with Italian marble floors and a partial front wall. Stained glass adorned the front of the teller windows, where Wilbert Stewart's two sons, Wilbert George "Bert" (left) and Clifford R. stand ready to help their customers. They worked at the bank with their father for many years. Bert passed away in 1942, and Clifford continued working until it was sold to Citizen's National Bank in 1949. The bank was never robbed, as the teller windows had pistols hidden underneath shelves.

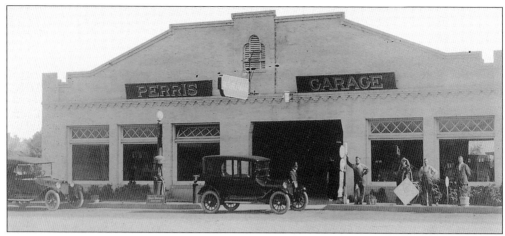

HOOK'S PERRIS GARAGE. Built in the 1920s by Rufus M. Hook Sr., son of Albert and Mabel, this garage was on the east side of D Street between Second and Third Streets. They sold Dodge and Studebaker cars, tires, and other automotive products. They were proficient in mechanical work on both automobiles and trucks. The business grew by adding other automobiles in the Chrysler family. When Rufus "Bud" Hook Jr. returned home from World War II, he took over the business from his father. Bud was a respected businessman and kept his customers happy and coming back. Bud passed away in 1981 after keeping the Hook legacy alive for 100 years.

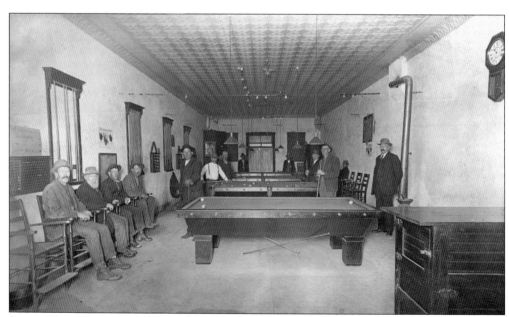

PERRIS POOL HALL. In 1920, the Perris Pool Hall was a popular place among the men. It was located on the east side of D Street between Third and Fourth Streets. The only person who can be identified is Frank Trujillo, standing fifth from left by the pool table.

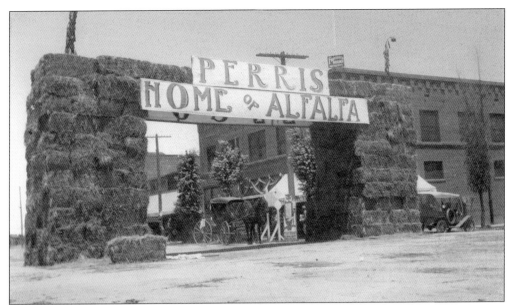

ALFALFA FESTIVAL. One of the earliest festivals in Perris was the Alfalfa Festival, with the first one being held on July 26, 1913. This photograph shows the northeast corner of D and Fourth Streets piled high with alfalfa bales. When a viable underground water supply was found, Perris Valley crops flourished, and alfalfa became one of the main irrigated crops. Perris Valley celebrated this great harvest with merriment.

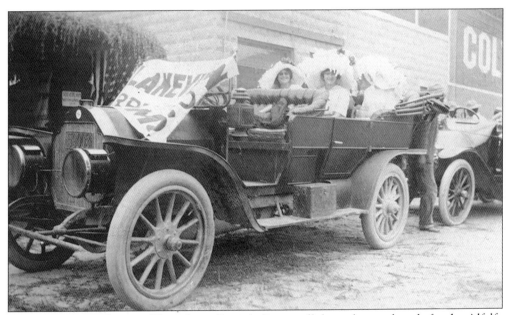

ALFALFA FESTIVAL LADIES. These fancy Perris ladies are all dressed up and ready for the Alfalfa Festival parade of 1915. The lady in the middle is Vera Akin, who was born to Henry and Mattie Akin in Perris in 1896. Alfalfa was one of the most important crops in Perris Valley for more than 100 years.

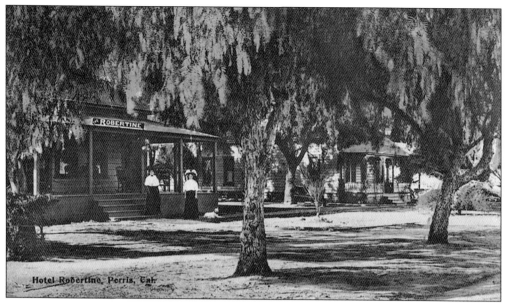
Hotel Robertine, Perris, Cal.

ROBERTINE HOTEL. A pleasant place to get a good night's sleep and a warm meal was this two-building hotel. One was for boarding, and the other had a kitchen and dining area. Many travelers from all over the country would stay there. It was open for business for many decades. After the hotel closed, the buildings were converted into private homes. The building on the left burned down several years ago. The remaining building is still a private home and has been occupied by members of the Stenlake family for several decades.

HARRY HUGHES. Coming to Perris as a railroad inspector, Harry Hughes stayed at the Robertine Hotel in the early 1900s. There, he met his wife, Guadalupe "Lupe" Trujillo. Lupe was a waitress in the hotel dining room, and according to the story passed down through the family, she spilled a cup of coffee on Harry, and they fell in love and got married. Harry and Lupe lived in Perris, where they farmed and raised two boys, Ralph and Norman.

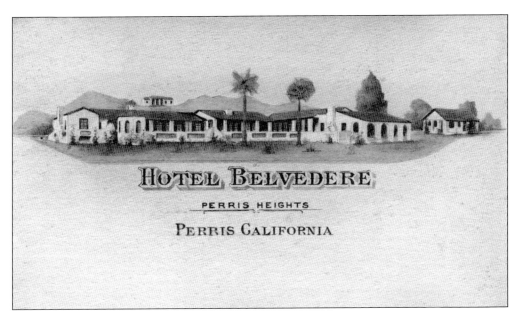

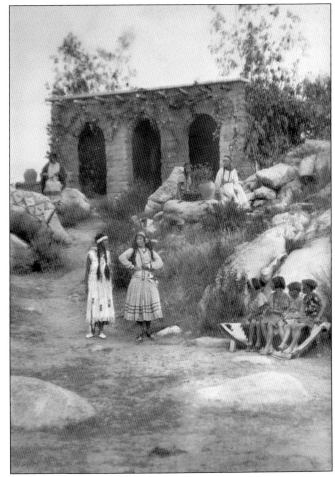

**HOTEL BELVEDERE.** This attractive resort was built west of Perris in the Perris Heights area in the 1920s. The Hotel Belvedere became a popular escape for movie stars looking to have a restful weekend. It had a scenic view of the Perris Valley and the surrounding mountains. In the 1940s and 1950s, it was known as the Palomar Boys School, a privately run institution. Today, it is the Hacienda Rehabilitation Center for men.

**MOCKINGBIRD PAGEANT.** This outdoor play was unique to Perris. It was performed during 1927 and 1928 in the rocky hills west of downtown. It was known as a "desert fantasy." The cost of admission was $1 per person or $2.50 for a family. The Los Angeles Philharmonic Orchestra provided music for the play. In those days, it must have been one of the most exciting things to ever come to Perris.

**Felicita "Happy" Bernasconi and Valentine Reynolds.** This couple was married on September 11, 1910, in the Southern Hotel that her mother and father had built in 1886. For a brief time, they lived in Ontario, California. Returning to Perris, they opened the Reynolds Hardware and Plumbing Store in 1913. They had two sons: Elmer and Robert "Bud." Both the Bernasconi and Reynolds families have a rich history in Perris Valley.

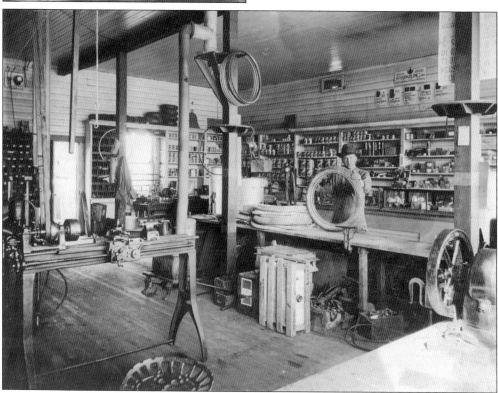

**Reynolds Hardware and Plumbing Store.** Opened in 1913, the Reynolds Hardware and Plumbing Store was owned and operated by Valentine Reynolds and his wife, Felicita "Happy" Reynolds. They sold supplies to the people of Perris Valley, met the farmers' needs, and installed water tanks for their rural customers. Tragedy struck in 1936 when Valentine Reynolds passed away. Being a strong and hardy woman, Happy, as everyone called her, ran the store with her sons Elmer and Bud for another 40 years.

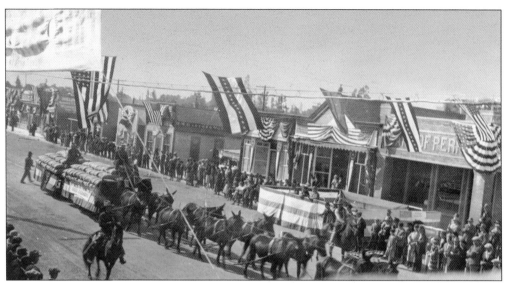

STREET PAVING CELEBRATION, 1925. To commemorate the completion of paving the highway on D Street in Perris, all the people in town turned out to celebrate with a parade down the new street. Many citizens and businesses participated with floats, horses, wagons, and cars. The town was decorated with patriotic flags showing the festive spirit of the day.

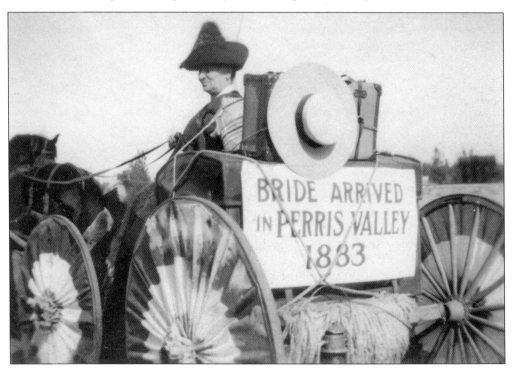

MARCELLINA BERNASCONI. Shown riding in the parade, Marcellina Bernasconi marks her arrival to town with a festooned wagon pulled by two beautiful horses and a sign that reads, "Bride Arrived in Perris Valley in 1883." She was one of the strongest and most caring pioneer citizens of Perris. A business-minded woman, she built the Southern Hotel as an investment. Later, she moved into the hotel with her children so that they could attend school.

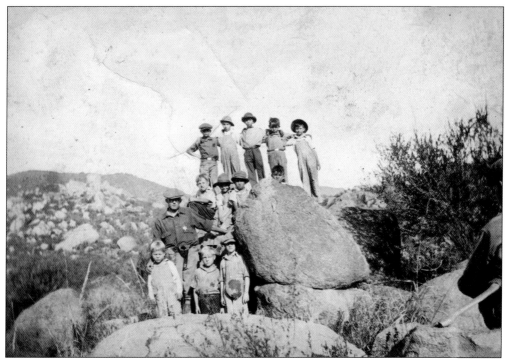

BOY RANGERS OF AMERICA. A pre–Boy Scout troop was organized in Perris around 1926. This photograph was taken near the Good Hope Mine in Perris. From left to right are (first row) troop leader Mr. Slatten, Bill Quigley, Robert Neville, and William Sheldon with the canteen; (second row) Stanley Benton, Earl Carter, August Trujillo (behind rock), and Stanley Trujillo; (third row) Regan Thompson, unidentified, Melvin Hardy, unidentified, and Carl Carter.

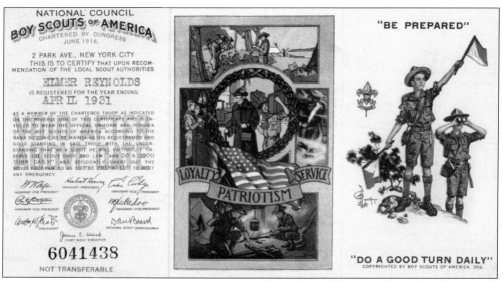

BOY SCOUT CARD, 1931. As a Boy Scout, Elmer Reynolds was given this card in 1931. He is the grandson of Bernardo and Marcellina Bernasconi and the son of their daughter Felicita and Valentine Reynolds. Elmer and his brother Bud were Boy Scouts growing up in Perris.

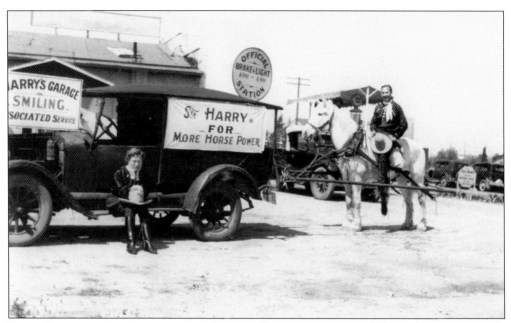

PERRIS LIVESTOCK DAY PARADE, 1939. Perris resident Harry Hynes is all dressed up Western style waiting to ride his horse in the Livestock Day Parade. His wife, Edith, is sitting on the running board of the truck, which is decorated with signs advertising Harry's Garage. Harry and Edith both enjoyed celebrating the events in Perris.

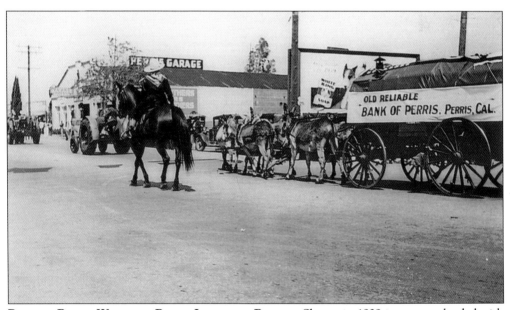

BANK OF PERRIS WAGON IN PERRIS LIVESTOCK PARADE. Shown in 1939 is a wagon loaded with grain and pulled by mules advertising the Bank of Perris. FFA and 4-H members from the valley would bring their animals to be judged and win ribbons. Part of the festivities was an exciting carnival. (Courtesy of John Lauda.)

**MR. AND MRS. J.L. RAGSDALE.** As designers and builders of the Rock House, the Ragsdales were owners of an oil distribution business and service station at Third and D Streets in Perris. The couple handpicked every rock that was used in building the house for smoothness and size. They had them trucked up to the construction site in Model T trucks by the Fred Hare Trucking Company of Perris.

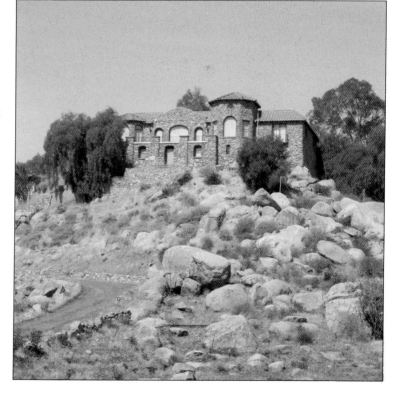

**ROCK HOUSE ON THE HILL.** This unique house is one of Perris Valley's most famous and intriguing landmarks. Sitting on a hilltop on the west side of Interstate 215, it can be seen from miles away. Mr. and Mrs. J.L. Ragsdale built the house between 1928 and 1929, bringing tons of handpicked rocks from the Whitewater wash area of the Palm Springs desert.

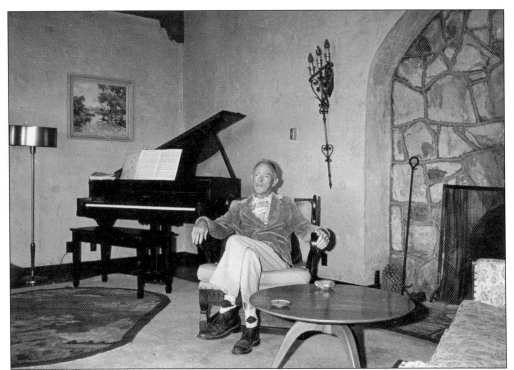

JACK SPILLANE. A most eccentric man, Jack Spillane sits comfortably in an antique chair inside the Rock House. He purchased the property in 1948 and lived there until he passed away in 1964. His wife, Dorothy, remained in the house until 1974. The large rock fireplace shows the massiveness of the house. (Courtesy of the Lake Elsinore Historical Society.)

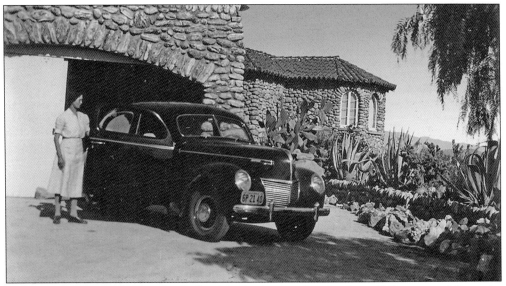

ROCK HOUSE GARAGE. Dorothy Spillane is shown standing by their 1940s automobile at the garage of the Rock House complex. The Rock House has had several owners over the years and has always remained a private residence. It continues to be one of the curiosities of Perris. It looks over the entire Perris Valley, and many photographs have been taken from its foothills.

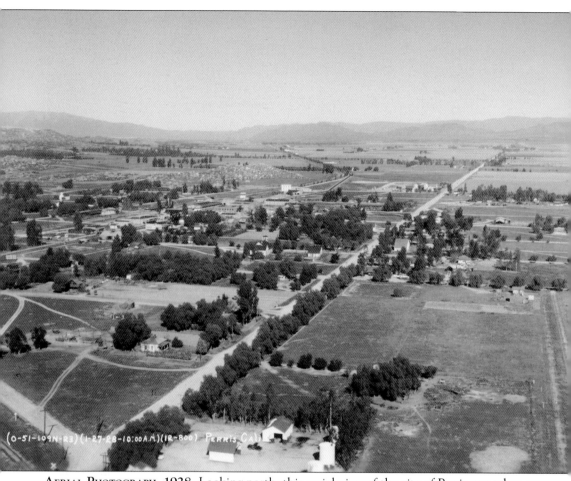

AERIAL PHOTOGRAPH, 1928. Looking north, this aerial view of the city of Perris was taken on January 27, 1928. It shows the sparsely populated city with the railroad tracks at the bottom left. Perris Boulevard is the large road running north and south in the center of the photograph, with D Street farther to the left. The historic First Congregational Church on Sixth Street can be seen at center, to the left of Perris Boulevard. The population at this time was approximately 800 people.

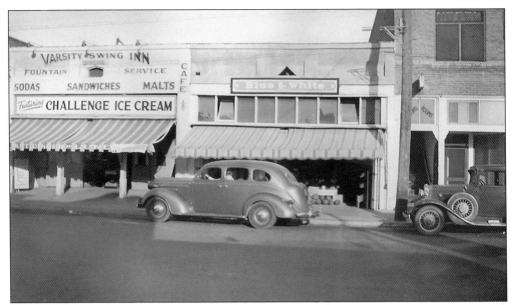

BLUE & WHITE MARKET. This shop was owned and operated by Al Nelson, who lived in the northern part of Perris. He made sure he had plenty of grocery items and fresh produce when in season from local farmers. This photograph taken in 1942 also shows the Varsity Swing Inn restaurant, a popular spot to eat during that time.

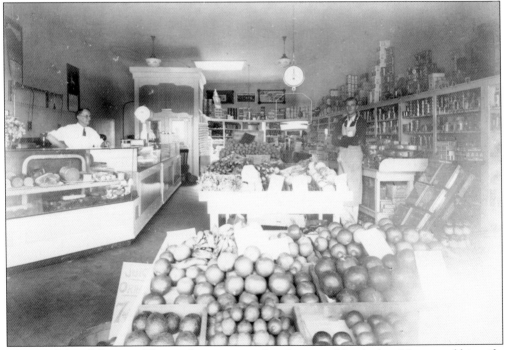

MOORE'S MEAT MARKET. This market was owned and operated by Arthur Moore and his wife, Vera Akin Moore inside the Blue & White Market. Arthur is seen standing on the left, behind the meat case. The Moores always had fresh meats and many returning customers. After Arthur passed away, Vera took over the business.

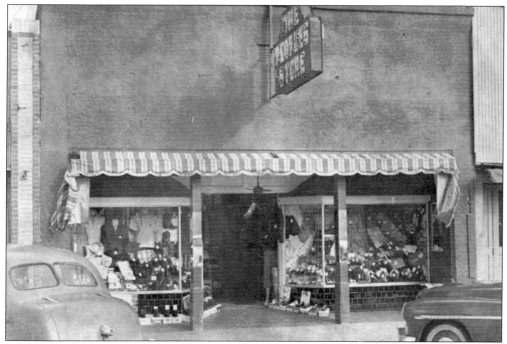

THE PEOPLE'S STORE. Robert Sr. and Clara Warren opened the People's Store at 329 South D Street in 1939. They served the community with clothing, shoes, hats, and other merchandise for the family. The store was an important part of the business scene in Perris for more than 70 years. Robert and Clara had two children: Robert Jr. and Sandra. After his parents retired, Robert Jr. and his wife, Jackie, managed the store until their son Bobby took over, and a few years later, they decided to close the store.

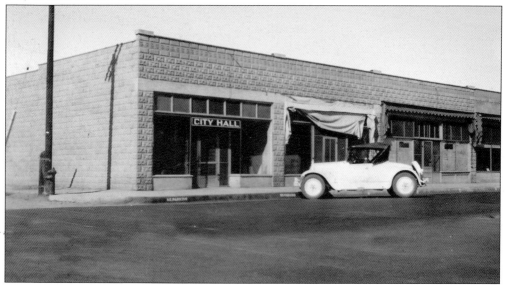

PERRIS CITY HALL. In the 1930s and into the early 1940s, city hall was located on the west side of D Street between Fourth and Fifth Streets. It seems D Street in Perris was the place to be and where everyone came to shop and take care of business. During that time, pioneer family member Mildred Dunsmoor Martin was the city clerk and worked in that capacity for 20 years.

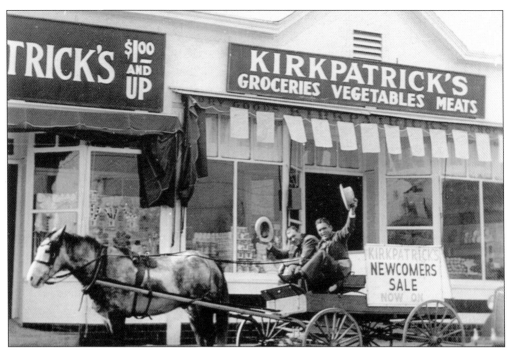

KIRKPATRICK'S MARKET. The Kirkpatrick Grocery Store has always been an important part of Perris's business history, offering fresh fruit and vegetables that were often locally grown. This 1941 photograph shows a couple of unidentified men advertising a sale at the store in a horse and wagon. The Kirkpatricks also owned a variety store adjacent to the grocery store. It was the one-stop shop of its time. (Courtesy of the Lou Anne Kirkpatrick Houck Collection, Perris Valley Museum Historical Archives.)

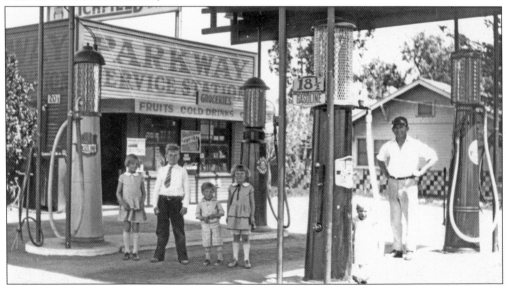

PARKWAY SERVICE STATION. Owned by the Burt Casner family, this service station was on the northeast corner of Fourth and A Streets in Perris. This c. 1928 photograph shows the Casner family. From left to right are Dorothy, David, Glen, Ruth, Margaret, and Burton. The price on the pump says 18.5¢ a gallon. Now that was the good old days! (Courtesy of Joan Casner Johnson.)

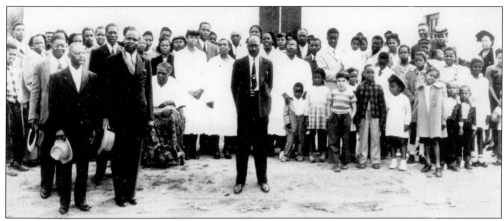

FIRST BAPTIST CHURCH. Moving to Perris in 1920 with her two nieces, Dora Nelson, a former slave, founded the first African American church in Perris in 1924. Services were held in a house at the northeast corner of Seventh and F Streets, and the Rev. Arthur Seaton served as the first pastor. After outgrowing the small church, a new First Baptist Church was built under the leadership of Rev. Alexander Cobbs and the men of the church at 277 East Fifth Street in 1947. The congregation is shown after marching to the new church singing "Highway to Heaven." (Courtesy of the David Rabb Collection, Dora Nelson African American Art and History Museum.)

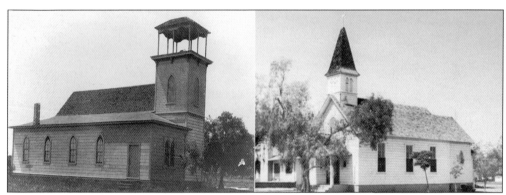

FIRST CONGREGATIONAL CHURCH AND CATHOLIC CHURCH. The first church built in Perris, First Congregational Church (left), was dedicated on October 2, 1887, only to be destroyed in a storm less than one year later. Eager to have their church rebuilt, the congregation worked diligently to get it reconstructed. The church was reopened in May 1889. A new church was built on A Street in 1967 to accommodate a growing congregation, and they sold the historic church to another denomination. On the right is St. James Catholic Church, which depended on traveling priests to serve the Catholics in Perris Valley. In 1909, the congregation was able to purchase the German Methodist Church, built in 1888, as their congregation had waned. The small church on Third Street served the parishioners for 50 years. At that time, a new church was built at Third and B Streets.

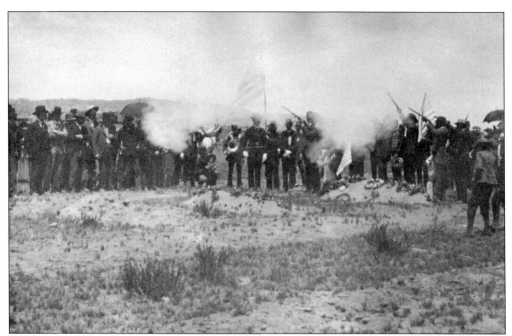

FIRST MEMORIAL DAY CELEBRATION. The Perris Cemetery held the first Memorial Day celebration in 1892, honoring Civil War veteran John Reynolds. It was a very festive day with the Rifle Squad and the Perris Band playing at his grave. Many Perris residents attended the ceremony and paid tribute to him.

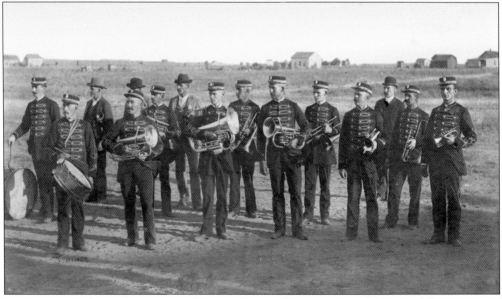

PERRIS BAND. This early Perris Band, pictured around 1900, was available to celebrate many of the local events. The day the Perris depot opened on March 16, 1892, the band was present to greet 250 people as they were departing the train. From left to right are bandleader Lew Tobey, Julius Rieger (a real estate agent), F.H. Carpenter, Charles Gyger (a gold miner), Frank Reynolds, Eugene Kimbell, Joe Rieger (son of Julius Rieger), D.D. Bevier, Price Hickey, James Mack, and Frank Beatty. The other men behind the band are unidentified.

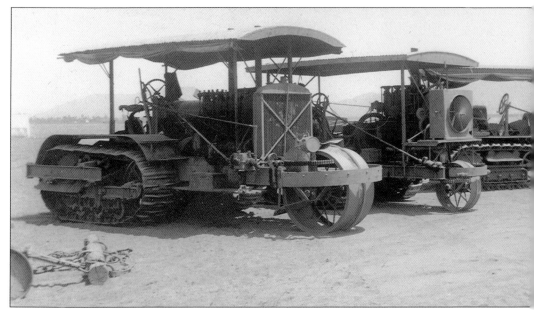

MARCH FIELD CONSTRUCTION. March Aviation Field was built at the north end of Perris Valley in 1918 to house the Army Air Corps. Shown are the Caterpillar tractors that were instrumental in building the field. Capt. W.H. Carruthers, USSC, was the officer in charge. Twohy Bros. Co.

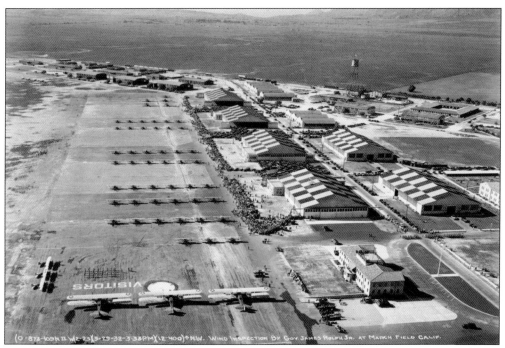

MARCH FIELD. This is an aerial view of March Field, which might have ceased operation had it not been for Frank Beatty, a pioneer family member in Perris. After World War I, the government was scheduled to close the base because the water had run dry. Just as they were getting ready to shut down the base, Beatty discovered water and saved the base from closure. The base has always been important to Perris Valley, as many residents were employed there.

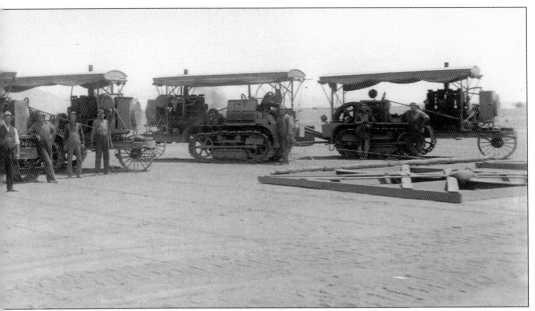

was the contractor, led by George W. Boschke, general superintendent; James Horan, assistant general superintendent; and Peter L. Ferry, head of teams and equipment. This location was later known as March Air Force Base and now is March Reserve Base.

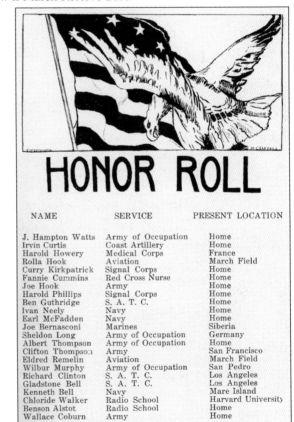

HONOR ROLL. In its 1918 yearbook, Perris Union High School honored those from Perris who went to fight in World War I. Listed are these brave and honorable men who served their country. Included are several pioneer family names such as Hook, Bernasconi, Kirkpatrick, Neely, and Cummins, just to name a few.

| NAME | SERVICE | PRESENT LOCATION |
|---|---|---|
| J. Hampton Watts | Army of Occupation | Home |
| Irvin Curtis | Coast Artillery | Home |
| Harold Howery | Medical Corps | France |
| Rolla Hook | Aviation | March Field |
| Curry Kirkpatrick | Signal Corps | Home |
| Fannie Cummins | Red Cross Nurse | Home |
| Joe Hook | Army | Home |
| Harold Phillips | Signal Corps | Home |
| Ben Guthridge | S. A. T. C. | Home |
| Ivan Neely | Navy | Home |
| Earl McFadden | Navy | Home |
| Joe Bernasconi | Marines | Siberia |
| Sheldon Long | Army of Occupation | Germany |
| Albert Thompson | Army of Occupation | Home |
| Clifton Thompson | Army | San Francisco |
| Eldred Remelin | Aviation | March Field |
| Wilbur Murphy | Army of Occupation | San Pedro |
| Richard Clinton | S. A. T. C. | Los Angeles |
| Gladstone Bell | S. A. T. C. | Los Angeles |
| Kenneth Bell | Navy | Mare Island |
| Chloride Walker | Radio School | Harvard University |
| Benson Alstot | Radio School | Home |
| Wallace Coburn | Army | Home |

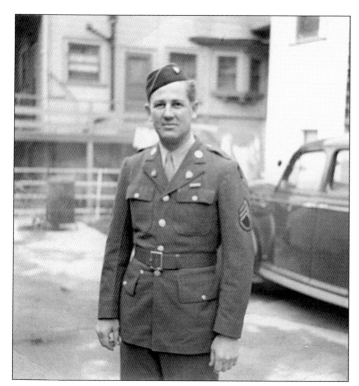

**World War II.** Many young men from Perris served in World War II. Pioneer family member Rufus "Bud" Hook Jr. was a proud Army soldier who fought bravely for his country. He received a Purple Heart for injuries he suffered during the war. He served from 1941 to 1945. Bud married his wife, Margaret Ann "Peggy" Selby Hook, in 1943 while he was in the service. They had one daughter, Christine, born in 1945.

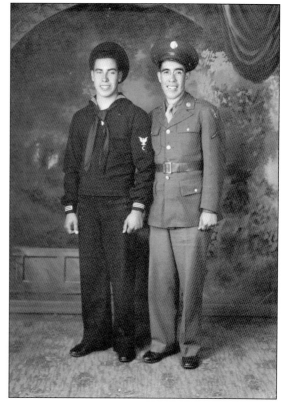

**World War II Servicemen.** Growing up in Perris, Ted Del Rio joined the Navy, while his brother Joe enlisted in the Army. These two Perris youths courageously served their country and returned home to pursue their careers. They are the sons of patriarch Bartolo Del Rio and his wife, Agustina Mora Del Rio. (Courtesy of Vincent Magana.)

**Brick Schoolhouse with Children.** In 1888, this attractive two-story brick schoolhouse was erected on A Street in Perris at a reported cost of $1,800. The lower floor housed the grammar school, and the upper floor was used for the high school. The building, which is no longer standing, was the first school built on the site of what is now the Perris Elementary School. (Courtesy of the Vera Akin Xydias Collection, Perris Valley Museum Historical Archives.)

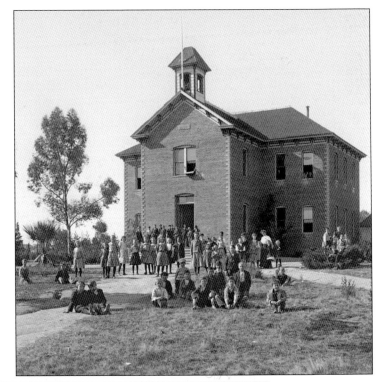

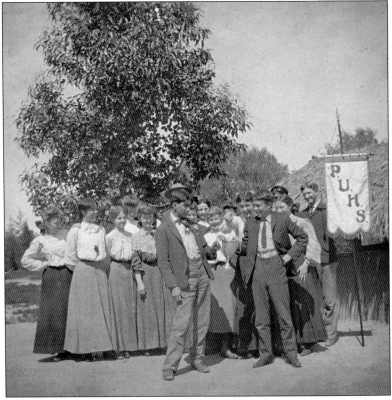

**Perris Union High School Debate Team.** The high school debate team of the large brick schoolhouse took home the trophy in 1905. This excited group of students appears to be enjoying their victory. Shown in front are the winning debaters, Paul Brown (left) and Albert Trujillo.

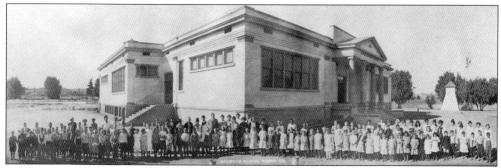

PERRIS GRAMMAR SCHOOL, 1913. The new Perris Grammar School was built on the same property as the old school on A Street in Perris. It had an auditorium with a stage on the upper floor and a cafeteria on the lower floor. The front entrance boasted impressive Roman columns and a star motif. Pictured are the students who attended the school.

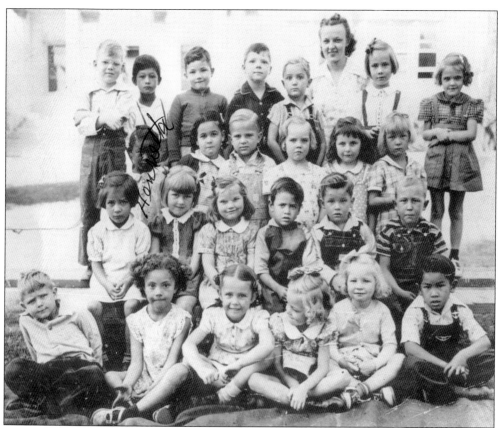

FIRST PERRIS KINDERGARTEN CLASS. In 1941, the first kindergarten class was established at the Perris Elementary School. The students pictured here are, from left to right, (first row) Wilbert Thomas, Dora Espinosa, Mary Hanifin, Geraldine Matthews, Carla Hill, and Billy Chung; (second row) Carmen Rodriquez, unidentified, Bessie Haynes, two unidentified, and Floyd Johnson; (third row) Henrietta Taylor, Janet Garat, three unidentified, and Elizabeth Ray; (fourth row) Billy Knittel, unidentified, Roger Honberger, Glenn Stewart, Maynard Small, teacher Miss Bren, Lou Ann Kirkpatrick, and Suzanne Cummings. (Courtesy of Roger Honberger.)

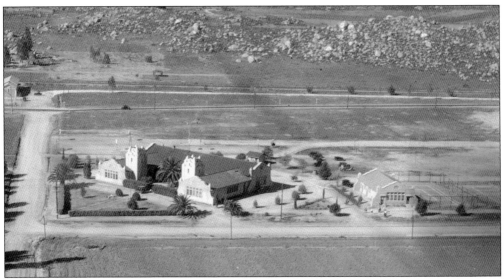

PERRIS UNION HIGH SCHOOL. A new Perris Union High School was built on the northwest corner of Perris Boulevard and San Jacinto Avenue in 1910. It was a beautiful mission-style building with two bell towers; a second building was constructed to the north. As can be seen in this aerial photograph taken in 1928, it had bare ground all around it. Students from Val Verde, Good Hope, Nuevo, Lakeview, Romoland, Homeland, Menifee, and even as far away as Winchester were bused to the school.

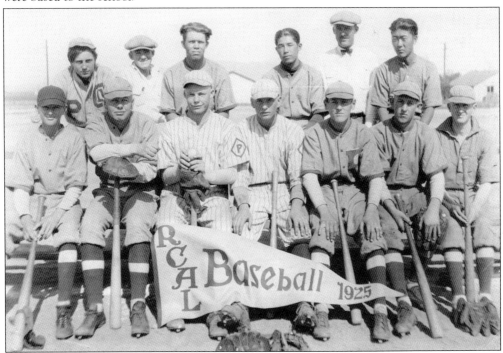

PERRIS UNION HIGH SCHOOL BASEBALL TEAM. In 1925, the Perris Union High School baseball team took home the Riverside County All League championship. The players' names are unknown. Baseball continues to be the favorite pastime of the people, just as it was back then. They must have made their families and the town very proud.

NUEVO GRAMMAR SCHOOL. The redbrick schoolhouse pictured with the American flag hanging in front was a beautiful site for these students in 1927. They are all dressed up in their costumes for a Thanksgiving program. Bob Walker, kneeling in front, is the only one identified. He is dressed as Hiawatha. (Courtesy of Sharon Walker Johnson.)

NUEVO SCHOOL, 1927. The entire school is pictured with their teacher Mrs. Freeman. Bob Walker is third from left in the front row, and his brother Clarence is standing to the right of Mrs. Freeman in the back row. Also among the students is Lawrence Cena, who grew up in Nuevo and became president of the Santa Fe Railroad. His exact location in the image is unknown. (Courtesy of Sharon Walker Johnson.)

FULL VIEW OF NUEVO SCHOOL. This photograph provides a full view of the Nuevo School with students standing in front. It looks like the trim had been painted white to spruce it up. It was an era of small schools and country farms. The historic Nuevo School closed in 1952 when a new school was built on Lakeview Avenue. There, it was combined with the Lakeview School and became known as the Nuview School. The old school, which is still standing, has remained in private ownership over the years. (Courtesy of Marie Walker Spradlin.)

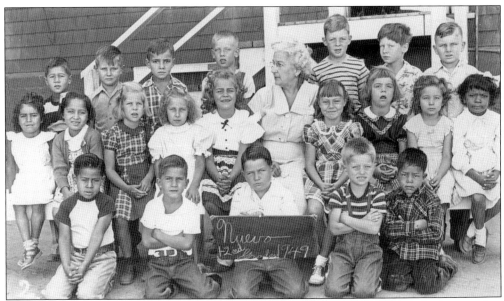

NUEVO SCHOOL, 1949. These first and second grade students are pictured with their teacher Hazel Forthrum at the old redbrick Nuevo School in 1949. Among the students in the front row is Pete Parker, who is seated second from left, and the first four boys standing in the back row are, from left to right, Dick Walker, Martyn Embertson, Benny Archibeck, and Gordon Perine. The other students are unidentified.

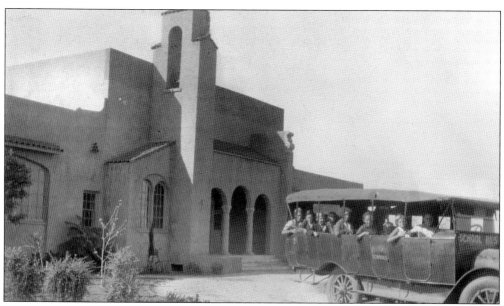

ROMOLAND SCHOOL. The Pacific Development Company of Long Beach built this school in 1918–1919. They were land promoters who came into the area to subdivide and sell five-acre lots. Those purchasing the parcels were told the land was ready to grow figs, grapes, lemons, oranges, and other crops. What the buyers later found is they did not have enough water to produce them. The promoters were later convicted of mail fraud and sent to jail. This school was used until 1955, when a new school was built on Antelope Road. Still standing today, the building is used by Datatronics, an award-winning company. (Courtesy of Richard Hewitt.)

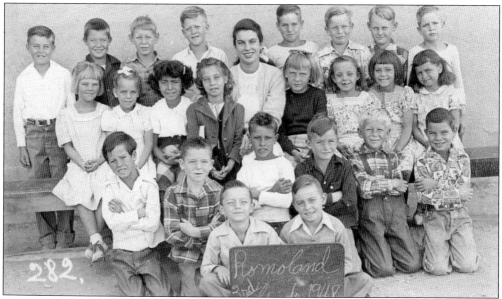

ROMOLAND SCHOOL, 1948. The Romoland School had its fair share of students in the valley with their parents temporarily harvesting crops. Most students were from families living in the Romoland or Homeland areas. Among this third grade class are Kent Ashley, holding sign at left in the first row; Della Lopez, third from left in the third row; and Mike Ashley and Fritz Schain, first and second from left in the fourth row. (Courtesy of Eileen Hanifin Schain.)

VAL VERDE SCHNEIDER SCHOOL, c. 1910. Not much is known about the Schneider School other than it was the first school built in the Val Verde area in 1884. The story told to the museum is that, after World War I, the German name of the school was not in favor at the time, and it was changed to the Webster Grammar School. The school was located on Rider Street, east of where I-215 is today. The children of John and Marie Coudures walked two miles each way to attend school. (Courtesy of Lela Humphries Willliams and Fred Williams.)

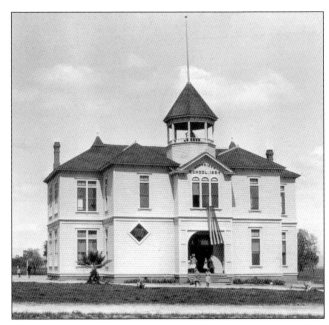

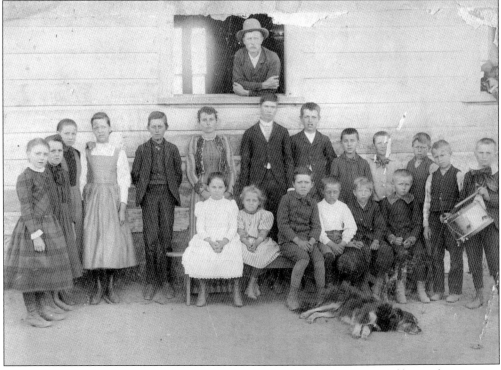

SCHNEIDER SCHOOL, 1890s. This photograph given to the museum is tattered but such a treasure. The only children known to attend the school in this early time were the Martin brothers, Harlan and John. Martin Street was named for their family. The road later became the Ramona Expressway. The Val Verde School was built on Martin Street in 1928, according to Louise Coudures Martin's story in their pioneer family book at the Perris Valley Museum Historical Archives. (Courtesy of Jeanne Martin Schulte and Janice Martin Smith.)

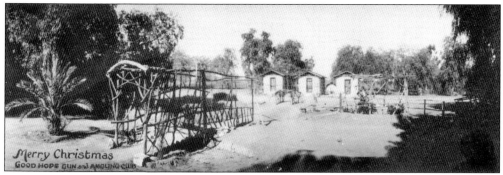

GOOD HOPE COUNTRY CLUB. In 1923, John Otto (J.O.) Walser, a land developer and investor from Los Angeles, purchased several hundred acres in Good Hope from the owners of Woodward's Mountain Glen in the area west of Perris Valley. He built cabins and a beautiful clubhouse for entertaining. People from the city would buy five acres as a retreat where they could grow gardens or fish and hunt on their property. Walser accumulated more than 2,000 acres, which he was successful in developing and selling over two decades. (Courtesy of Arlene Walser Allsop.)

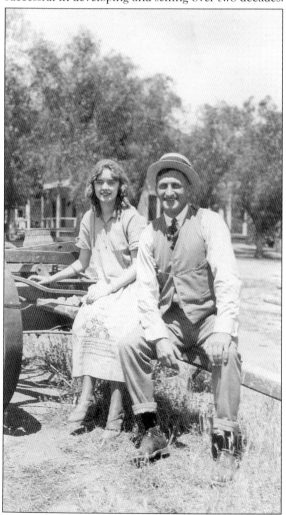

THE WALSERS. J.O. Walser and his wife, Theda, are shown relaxing on a piece of equipment at the Good Hope Country Club in the early 1920s. Two streets in the Good Hope area are named for the couple and the club that they established: Club Drive for the Good Hope Country Club, and Theda Street. They lived on the property until 1944, when it was sold. (Courtesy of Arlene Walser Allsop.)

**GOOD HOPE GUN AND COUNTRY CLUB.** This brochure shows a variety of activities available at the Good Hope Gun and Country Club in 1924. It was quite an entertaining place in those days. J.O. Walser sold property to many bachelors, and a friend of his even hosted a banquet in Los Angeles where women were invited to meet and marry the men. (Courtesy of Arlene Walser Allsop.)

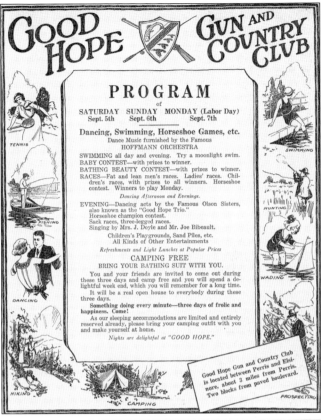

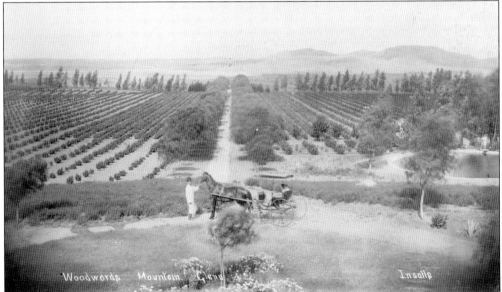

**WOODWARD MOUNTAIN GLEN.** Looking out over the glen in 1897, this view shows the many fruit trees farmed on the Woodward property in Good Hope. In 1923, developer J.O. Walser purchased the Woodward land. The Woodwards were instrumental in founding the Perris pumping plant, which brought water to many of the farms.

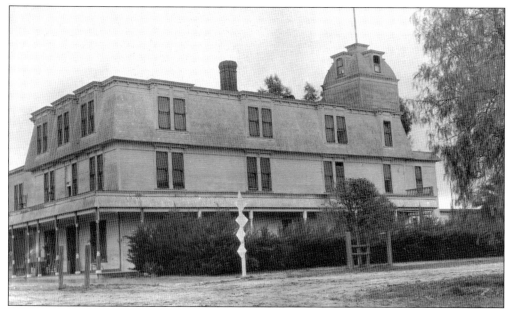

LAKEVIEW HOTEL AND POST OFFICE. This c. 1905 photograph of the Hansen Hotel built by Col. L.P. Hansen in Lakeview shows the hope the developers Frank E. Brown and Hansen had at the time. In 1899, the railroad actually came to Lakeview from Perris with railcars and a passenger car to great fanfare. The three story hotel eventually was rebuilt into a two story structure. It housed the Lakeview Store and Post Office. It has been remodeled and continues to house the store. (Courtesy of Lela Humphries Williams and Jim Williams.)

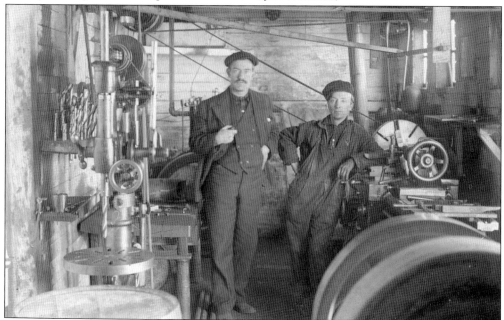

OLNEY BROTHERS. Although not much is known about the Olney family, this interesting photograph of the Olney brothers was taken at their home on Fourth Street in Perris. The Olneys were California miners in the early 1900s who were known to have operated in the Gavilin Hills west of Perris, where many mine claims were held.

HARRY SCHROEDER MACHINE SHOP. Harry Schroeder came to the Perris Valley in 1916. Schroeder was known as a genius in his trade as a master machinist. He was the most important person to the Perris farmers, who depended on him to fix their equipment. Schroeder was an inventor who built what was needed to get the job done. He built many potato diggers and other important farming machines. He worked in the Perris Valley for over 50 years until he retired in the 1970s.

MAYER STOCK FARM. Louis B. Mayer, owner of the Metro-Goldwyn-Mayer Studios in Hollywood, built this picturesque 500-acre farm in Perris on both the east and west side of Perris Boulevard, north of Orange Avenue, in the early 1940s. Pictured are the pristine horse stables. The farm raised several champion Thoroughbred racehorses and other domestic animals. A regulation racetrack for training the horses was also built. Surrounded by white painted fences, the farm was maintained to the highest degree. Mayer brought many Hollywood celebrities to stay at the farm, where he employed a staff of Perris residents. Part of it was sold to the Mormon Church in 1949. Farmer John Coudures also purchased part of the land. Today, the Triple Crown housing tract is located on the northeast portion of the property, and many of the streets are named for racehorses.

**FRANCIS HONBERGER.** In the mid-1930s, the first Perris volunteer fire department was founded by city leaders Francis Honberger, Banta Beatty, Frank Kitchen, Bob Johnson, Clyde Moore, Chuck Bonge, Walt Johnson, Bob and Sam Heidanus, Bill Hall, Dan Almquist, Paul Passage, and Charles Coleman. Together, they purchased a Model T truck and equipped it for firefighting purposes. Francis Honberger was officially appointed fire chief, and the new volunteer fire department was founded. Honberger was a very academic, athletic, and musical man who graduated from Perris Union High School in 1930. He met the love of his life, Agnes Cazas Freeman, while playing in a band at a dance at the Alamo School. The couple later eloped to Yuma. They have one son, Roger. (Courtesy of Roger Honberger.)

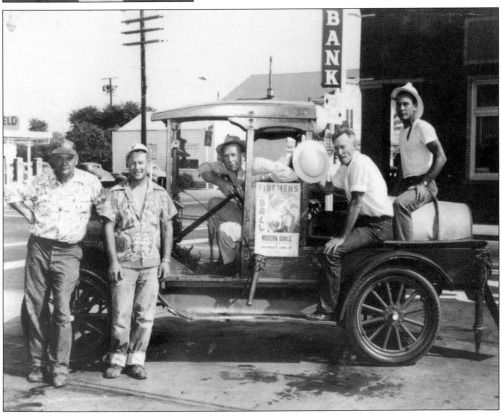

**ANTIQUE FIRE TRUCK.** This 1918 Model T fire truck is believed to be the first of its kind used by the volunteer fire department started in Perris in 1935. When it was replaced, the firefighters continued to use it for parades and special events. It is now owned by the Perris Valley Historical Museum, which still uses it for parades. A group of volunteer firemen is pictured here in the 1960s. From left to right are Fred Anderson, Bill Hare, Ed Nelander, Earl Gilbert, and Bert Wirebough.

# Two
# Legacy of Farming and Water

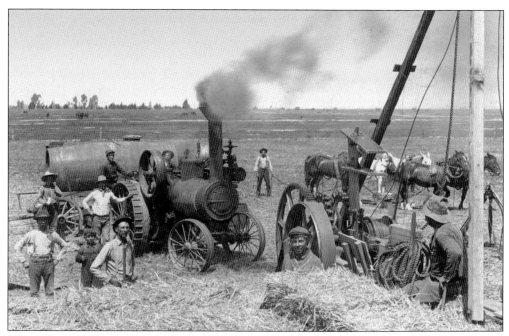

FRANK BEATTY. Perris pioneer Frank Beatty introduced the steam hay baler operated by a steam traction engine and a crew of 10 men. The men averaged 40 tons of baled hay per day. The hay baler was one of the most important pieces of farming equipment in the valley. Beatty took the hay baler to other towns to bale hay. He was a man of many talents, including mining, drilling wells, and just about anything else the town needed. He even saved March Field from closing.

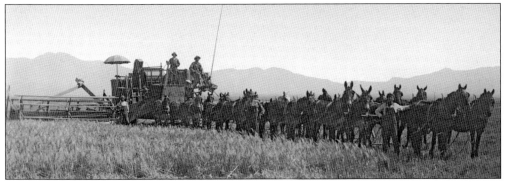

MULE TEAM. Owned by pioneer farmers John and Marie Coudures, this 20-mule team is shown pulling grain harvesters through one of their vast grain fields. Grain was a major crop in their farming operation. In addition to raising sheep, they also grew alfalfa, potatoes, sugar beets, and other various crops for more than 75 years.

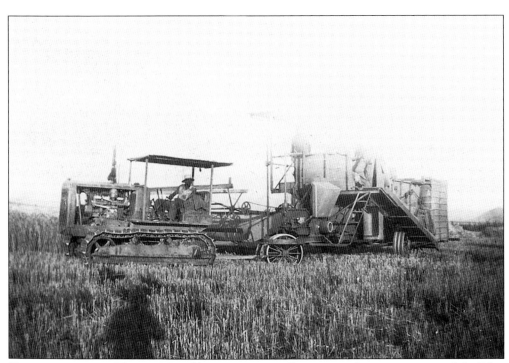

TRACKLAYER, 1937. This 1937 Tracklayer tractor is pulling a grain harvester as part of the John Coudures farming operation. This scene was typical of the Perris Valley harvesting season in the early 1900s. Dry grain farming was one of the major crops grown in the Perris Valley.

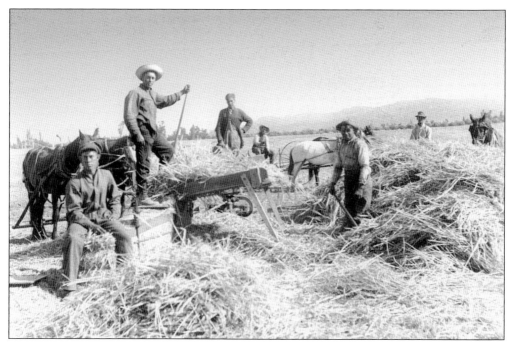

**MARTIN BROTHERS HARVESTING HAY.** Farmers Harlan and John Martin and crew are shown harvesting hay in the Val Verde area of the valley in the early 1900s. Different varieties of hay were important crops grown in Perris Valley over several decades. John Martin's son Clifford continued farming until the 1960s. (Courtesy of the Clifford and Louise Martin family.)

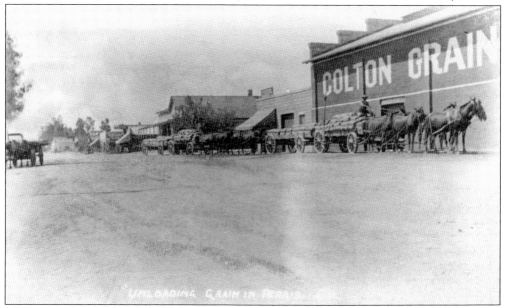

**COLTON GRAIN AND MILLING.** After the Nance building burned in 1905, Colton Grain and Milling reconstructed what was left of it into a warehouse milling operation. This photograph shows a line of impressive horse and wagons filled with sacks of grain ready to be stored until it could be milled or shipped out on the train. Another milling company, Lerners, used the building for several years after Colton Grain and Milling left Perris.

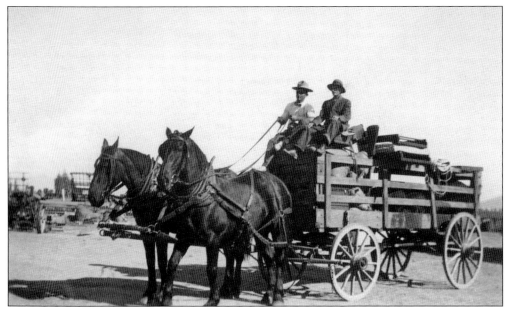

PERRIS FREIGHT SERVICE. These large wagons were used to deliver supplies from Perris businesses like Hook Bros. & Oak and other merchants. With many farms in the valley located out of town, it was a necessary service.

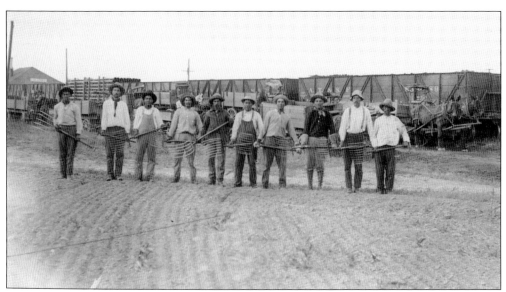

MORA AND DEL RIO FAMILY BUSINESS. The Mora and Del Rio families arrived in Perris in the early 1900s. They were industrious and strong. Several of the men started what they believed was a needed service to supply fertilizer for the hundreds of citrus groves and other varieties of fruit trees in the Riverside County area. They set up a fertilizer company and gathered manure from the many farms in the valley. It was then loaded for shipment via train. They were successful in their endeavor. (Courtesy of Vincent Magana.)

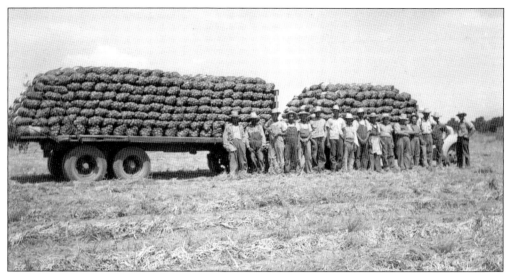

NORMAN WALKER & SONS. Norman Walker arrived in Nuevo in 1914. In the 1930s, his sons Clarence and Bob joined him to help run his farm. In addition to raising livestock, they grew potatoes, onions, alfalfa, and grain. Shown is an onion crop loaded onto two double trailers ready to go to market in 1943. Standing in front of the truck is the hardworking crew. (Courtesy of Marie Spradlin.)

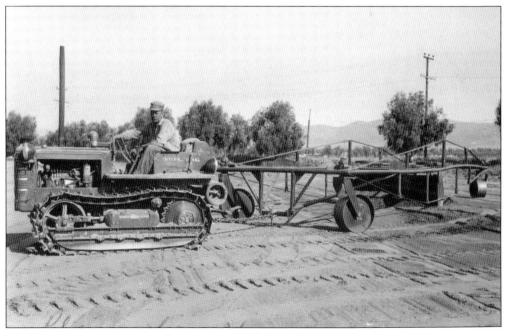

BOB WALKER ON TRACTOR. Farmers work hard to keep producing crops, and one piece of necessary equipment is a tractor. Bob Walker is shown in Nuevo on his 1940s International tractor pulling a self-made land plane to level the fields. Walker was always inventing his own apparatus since what he needed was not always available. (Courtesy of Marie Spradlin.)

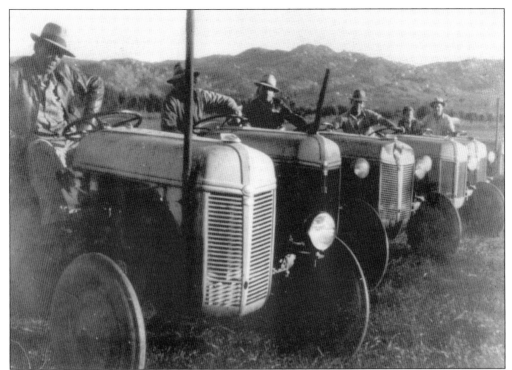

SMITH SIBLINGS WITH TRACTORS. The family of John Smith Sr. came to Nuevo in the 1920s to farm. His sons farmed thousands of acres over many decades. Pictured with their tractors are, from left to right, John Smith Jr.; brothers George, Roy, and Elmer; sister Betty Smith Yates; and brother-in-law Lee Yates. (Courtesy of David and Nancy Smith.)

SMITH BROTHERS POTATO SHED. When potatoes were in their heyday in the Perris Valley, the Smith brothers built a potato shed on C Street north of Fourth Street, adjacent to the Santa Fe Railroad tracks. They employed several men and women to work in the shed, unloading the trucks, grading the potatoes, or bagging and packing them onto the train or onto trucks to be shipped and sold. The property was sold to MetroLink to make room for parking and pickup areas. (Courtesy of Larry Smith.)

THE MOTTE BROTHERS. Pictured here are, from left to right, Frank Motte, John Motte, and Charlie Motte. They were large land owners and farmers in Perris Valley for several decades. Their father, Alfonse Motte, moved the family to Lakeview in the early 1920s. In the early years, they raised sheep, and when his sons were old enough, they formed Motte & Sons and grew a variety of crops including grain, alfalfa, potatoes, onions, and sugar beets. After their father passed away, the company name was changed to the Motte Bros. They continued farming until the 1960s, when they divided up the property. John continued to farm with his son Leon, Charlie got involved in land development, and Frank built the Quail Lake Golf Course with his son Franklin. (Courtesy of Motte Historical Museum.)

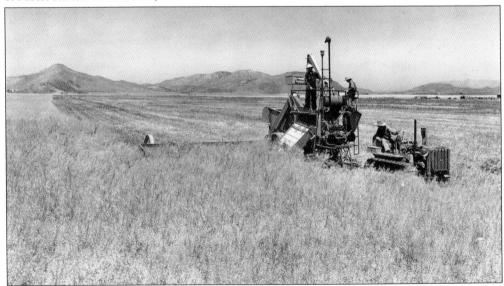

MOTTE BROS. FARM HARVEST. This early photograph shows the Motte brothers harvesting their crop in the heat of the summer at their Lakeview farm in the 1930s–1940s. The farm equipment used in those days is a far cry from the modern equipment of today, as it now takes only one person in an air-conditioned tractor to cut hay. (Courtesy of Motte Historical Museum.)

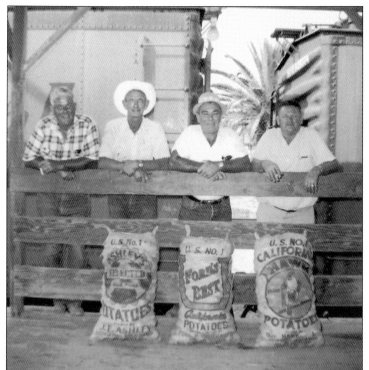

ASHLEY POTATO SHED. Potato sheds were numerous in the Perris Valley, and this photograph was taken in Lucy Ashley's shed in Romoland. J.E. Lucy Ashley (second from left) is pictured behind his Ashley's Selected brand potato sack. Next to him is Ford Underwood (third from left), standing behind his Ford's Best brand. The other two men are unidentified. (Courtesy of Marion and Mary Ashley.)

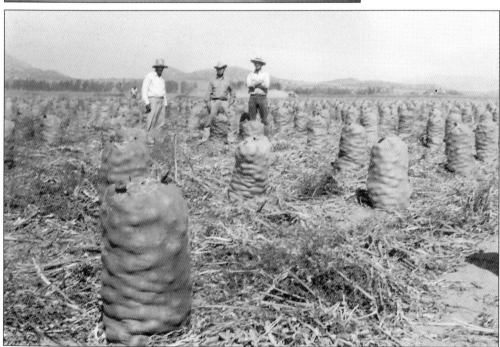

TATUMS FARMING POTATOES. The Tatum brothers were early farmers in Perris Valley. From left to right are Marion "King Fish," Clyde, and Harry. They lived in Nuevo and farmed potatoes for many years. Marion's son Le Verne "Spud" Tatum built a large potato shed on Case Road in Perris that is still standing today but used for other purposes. (Courtesy of Marion and Mary Ashley.)

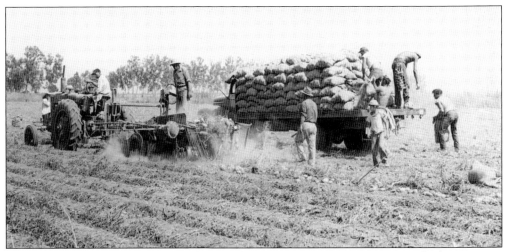

HARRY HUGHES & SON. Harry Hughes and his son Norman grew potatoes and other crops in Perris for many years. Harry and his wife, Lupe, had a farm north of Perris near Rider Street and Evans Road. This photograph shows how they harvested their potatoes. The tractor is pulling a potato digger, with the men bagging and loading them on the truck. They were then taken to the Hughes potato shed for processing.

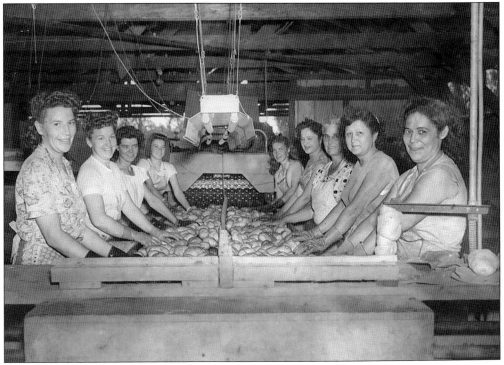

GRADING POTATOES AT HUGHES SHED. Before potatoes could be sold at market, one of the processes involved grading them. The potatoes would travel on a conveyer belt to these ladies, who would sort them into certain bins according to their size and quality. The big ones were considered baking potatoes, and the small ones were called peewees. The best ones without flaws would be graded as a No. 1, and the odd ones would be a No. 2. The potatoes would then be bagged into a sack that was sewn shut, put on a hand truck, and loaded onto a railcar or truck for shipping.

## - PERRIS VALLEY CROPS -

### Official report of Riverside County Agricultural Commissioner

#### CITRUS

| | |
|---|---:|
| Grapefruit | $ 6,910.00 |
| Lemons | 815.67 |
| Miscellaneous | 346.61 |
| Navels | 21,130.20 |
| Valencias | 9,131.52 |

#### DECIDUOUS

| | |
|---|---:|
| Apricots | 1,800.00 |
| Figs | 110.00 |
| Grapes - Wine | 39,000.00 |
| Olives | 1,800.00 |
| Walnuts | 460.00 |

#### TRUCK CROPS

| | |
|---|---:|
| Asparagus | 3,105.00 |
| Strawberries | 4,530.00 |
| Corn - Sweet | 280.00 |
| Cucumbers - Misc. | 2,400.00 |
| Cantaloupes | 32,725.00 |
| Persian Melons | 3,230.00 |
| Watermelons | 217,000.00 |
| Onions - Dry | 234,000.00 |
| Potatoes - Fall Crop | 726,000.00 |
|           Spring Crop | 3,289,950.00 |
| Squash - Banana | 53,760.00 |

#### FIELD CROPS

| | |
|---|---:|
| Alfalfa - Hay | 356,400.00 |
|       Seed | 24,894.00 |
|       Straw | 7,040.00 |
| Beans - Dry | 1,812.00 |
| Beets - Seed | 215,353.78 |
| Corn - Field | 8,505.00 |
|       Milo Maize | 24,000.00 |
| Grain - Barley | 359,000.00 |
|       Oats | 70,200.00 |
|       Wheat | 130,000.00 |
| Grain Straw | 10,000.00 |
| Hay - Barley | 33,600.00 |
|       Oats | 32,000.00 |
| Permanent Pasture | 64,400.00 |
| **TOTAL** | **$5,985,788.78** |

CROP REPORT, 1947. Every year, the Department of Agriculture would publish a report for each area that showed what the farms had produced. As seen here, potatoes were the most lucrative crop in 1947. It is interesting to see what crops were grown in Perris Valley and how much income they produced. Farmers did not know what the market would bear from year to year. Some years they did very well, while others were a disaster.

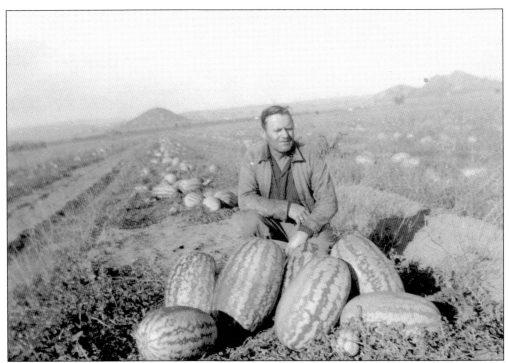

VAN HOUTEN WATERMELON FARM. In the 1930s and 1940s, Lloyd Van Houten grew watermelons on his farm north of Perris in the Rider Street and Evans Road area. He is shown here with several enormous freshly picked watermelons. His son Tom married Bette Hook from the pioneer Hook family. (Courtesy of David Ellis Van Houten.)

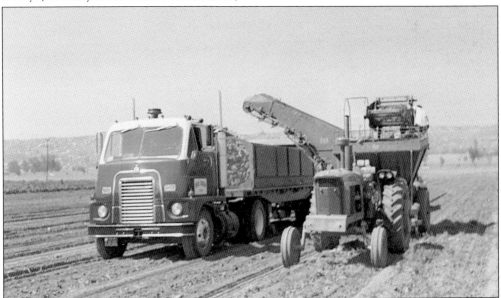

SUGAR BEET HARVEST. The Coudures farming operation shows a tractor harvesting sugar beets, then dropping them into a truck to haul to the processing plant. There were no facilities for sugar beets in this area, so they had to be trucked to Los Angeles. After water became too expensive to grow potatoes, farmers grew sugar beets for a few years. (Courtesy of the Coudures family.)

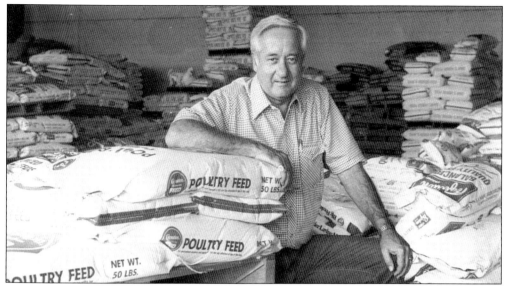

JOHN R. HARRISON, THE FARMER'S FRIEND. Owner of Dan's Feed & Seed in Perris, John R. "Johhny" Harrison is pictured surrounded by sacks of feed and seed in his store. He was the best known agricultural supplier in Perris Valley and the surrounding areas. He catered to both small and large farmers and many horse ranches. He enjoyed raising race horses at his ranch in Menifee. He married Jan Perry of Perris and they had two children, Tammy and Dicky. Johnny was very active in the community and supported the 4-H and FFA students and purchased many of their animals. A building at the fairgrounds is named Harrison Hall in his honor for being a dedicated fair director for many years. Johnny passed away in 2007. (Courtesy of the Harrison Family.)

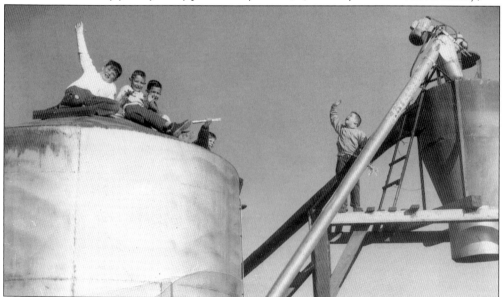

PERRIS FEED LOT. The Perris cattle feed lot was located on northeast San Jacinto Avenue in the Redlands Boulevard area. Tom Hanifin had several head of cattle there. After Tom passed away in 1964, his son John and his sons fed the cattle until they went to market. Boys being boys and having fun, they climbed up on the feed tank. From left to right are David, Terry, and Tommy, along with Danny Hanifin standing on the right.

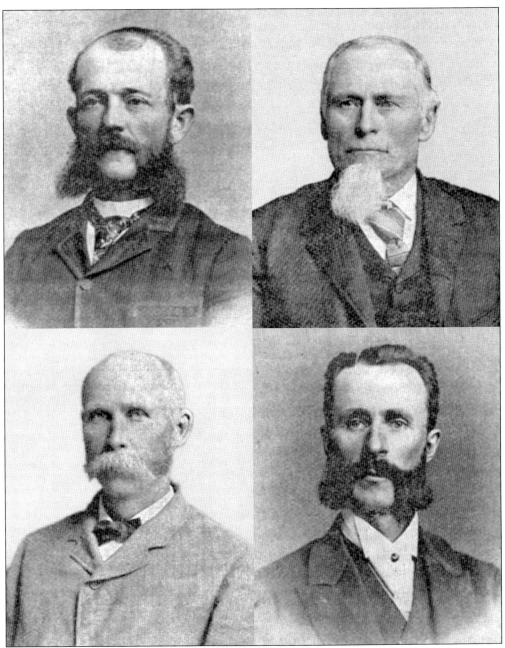

PERRIS IRRIGATION DISTRICT. The Perris Irrigation District was organized by order of the San Bernardino County Board of Supervisors in 1890. (Riverside would not become a county until 1893.) Supervisors partitioned the area into five divisions, and on May 20, 1890, an election was held to fill the elective offices. Shown here are directors (clockwise from top left) J.W. Nance, Division 1; Israel Metz, Division 2; Dr. J.W. Perry; and George P. Oaks, Division 3. Not pictured are W.F Warner, Division 4, and C.T. Gifford, Division 5. On June 13, 1890, Nance was elected president, with Dr. J.W. Perry as secretary.

PUMPING PLANT OF WOODWARD & SONS. William. D. Woodward and his sons G.C. and C.W. had one of the finest alfalfa ranches in east Perris. They built a water pumping plant at San Jacinto Avenue and G Street in Perris. Taken in 1907, this photograph shows Woodward and his family watching the water flow. His land is now irrigated by a 50-horsepower gasoline engine and a No. 8 centrifugal pump. The water stands 28 feet from the surface. They also owned the Woodward Mountain Glen property in Good Hope.

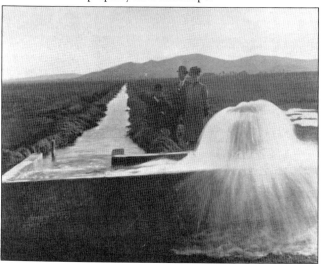

ALFALFA RANCH OF CRANE AND FAVORITE. O.J. Favorite, an early Perris settler, saw opportunities in this valley, and soon his relative A.T. Crane arrived. Together, they accumulated 700 acres. Crane also purchased 500 acres in the Val Verde area. Each ranch was planted with alfalfa and had a separate pumping plant. Water was pumped by 60-horsepower gasoline engines and a No. 10 centrifugal pump. The water was 125 feet deep. Favorite (seated) is pictured here with Crane and his wife.

TEMESCAL WATER COMPANY. In 1901, the Temescal Water Company, comprised of several wealthy citrus growers, built this power plant in Ethanac to pump water to their citrus groves in Corona. They purchased approximately 3,000 acres of land in the area (later known as Romoland) and leased it out to local farmers. After several years of pumping water to Corona, the local farmers' water source was running dry. Lawsuits were filed, and eventually, the plant was shut down. Ethanac was named for Ethan Allen Chase, one of the citrus growers.

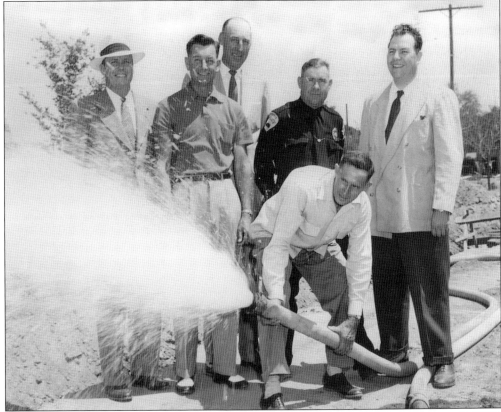

EASTERN MUNICIPAL WATER DISTRICT. In the 1930s, the Metropolitan Water District (MWD) built the San Jacinto Tunnel to bring water from the Colorado River to Los Angeles. The tunnel created problems for Perris Valley when enormous leakage caused the water tables to drop. In 1944, concerned area farmers formed the San Jacinto Protective Water Committee to voice their concerns to MWD. Despite considerable negotiations, MWD eventually agreed to supply water to Perris Valley after failing to correct the leakage. In 1950, the Eastern Municipal Water District (EMWD) was formed as a member of MWD. EMWD delivered water to Perris in 1953. From left to right are Johnny Colb, LaVerne "Spud" Tatum, Floyd Bonge, Mayor Marvin Wells (holding hose), Banta Beatty, and Doyle Boen. (Courtesy of Eastern Municipal Water District.)

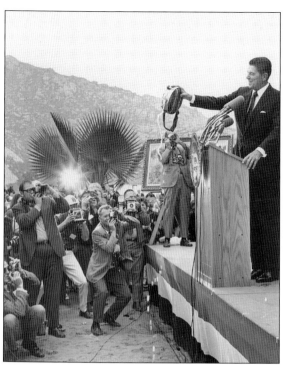

LAKE PERRIS DEDICATION. On October 28, 1970, California governor Ronald Reagan is shown pouring water from the Feather River in Northern California from a canteen at the dedication ceremony for Lake Perris, marking the delivery of water into the lake. Lake Perris was built as part of the State Water Project. (Courtesy of Eastern Municipal Water District.)

LAKE PERRIS CONSTRUCTION. The construction done to build the dam at Lake Perris was an enormous undertaking but one that was necessary to take care of the water needs of the growing area. It took until 1974 before it was completed and filled with water. (Courtesy of Eastern Municipal Water District.)

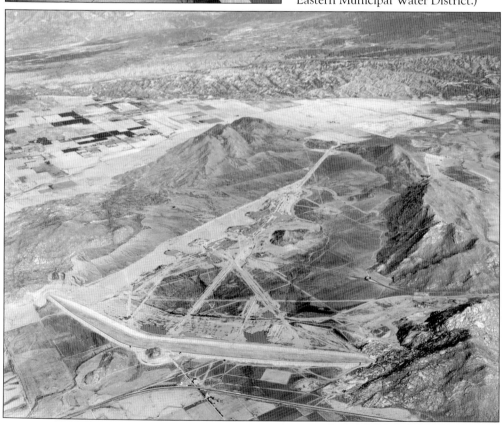

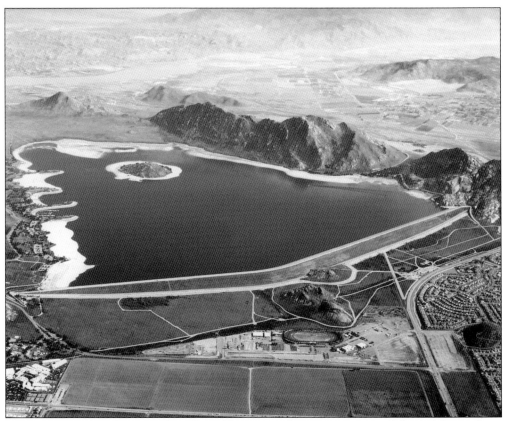

LAKE PERRIS. The lake opened to the public on April 7, 1974. As part of the California State Park system, Lake Perris is a popular destination for visitors from all over the region. The lake covers approximately 2,000 acres, and its recreation area is used for boating, fishing, waterskiing, biking, rock climbing, and more. The Ya'i Heki' Regional Indian Museum is also located here. (Courtesy of Eastern Municipal Water District.)

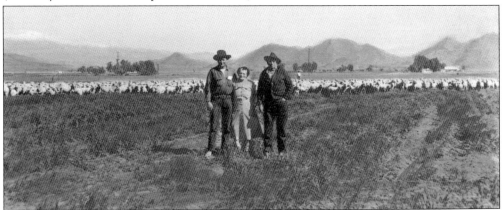

COUDURES SHEEP FARMING. Longtime Perris Valley farmers John Coudures Jr. and his mother, Marie, and father, John Sr., are pictured with their sheep in the background. They are standing on the property where Lake Perris was built. Both John Sr. and John Jr. were instrumental in the formation of the Eastern Municipal Water District, and John Jr. served as a director on the EMWD board for several years. (Courtesy of the Coudures family.)

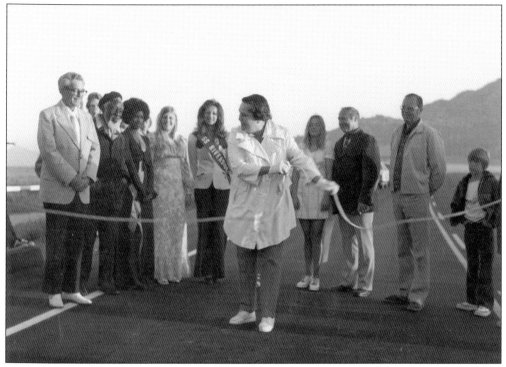

LAKE PERRIS OPENING DAY RIBBON CUTTING. When Lake Perris opened on April 7, 1974, it was a festive and exciting day with thousands in attendance. Shown in this photograph are (far left) Jack Savage, Clarence Muse, and his wife, Ena; (center) Perris Valley Chamber of Commerce president Roby de Francisco cutting the ribbon; and (far right) chamber vice president Marion Ashley and son Tom Ashley. The others are unidentified.

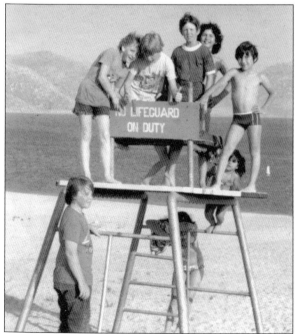

KIDS AT LAKE PERRIS. These children are enjoying opening day at Lake Perris, climbing on an off-duty lifeguard tower. The lake was the perfect place to take children for fun and entertainment. Most families brought picnic lunches and spent the entire day. Among those pictured are Jamie Hanifin, Kevin Hanifin, Tom Ashley, and Ralph Keyes. (Courtesy of John Hanifin.)

# Three

# PIONEERING FAMILIES

**BERNARDO AND MARCELLINA BERNASCONI FAMILY.** The Bernasconis were one of the earliest pioneer families in Perris. From left to right are Felicita, Bernardo, baby Joseph, Marcellina, and Matilda. They had three other children after this photograph was taken: twin daughters Stella and Edith and son Ernest. The children were all born at the Lakeview Hot Springs home, but later, Marcellina moved to the Southern Hotel in Perris, where she finished raising her family and remained until she passed away.

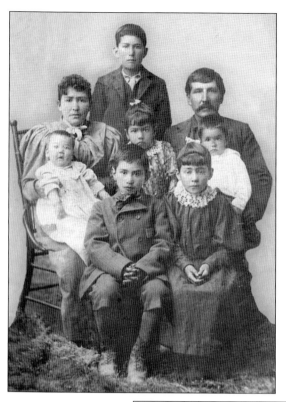

**DARIO TRUJILLO FAMILY.** Dario's grandfather is Lorenzo Trujillo, from one of the most historic families in Riverside and San Bernardino Counties. Coming from the Aqua Mansa area of Riverside, they tended sheep in the Gavilan Hills and Good Hope area west of Perris. They also mined gold, and if the legacy of the Good Hope Mine is true, Dario's father, Doroteo, discovered this very important mine. From left to right are (first row) Albert and Guadalupe; (second row) Doreteo's wife Sarah holding baby Dario, Esperanza, Dario, and son Sellio. Standing in the back is Frank.

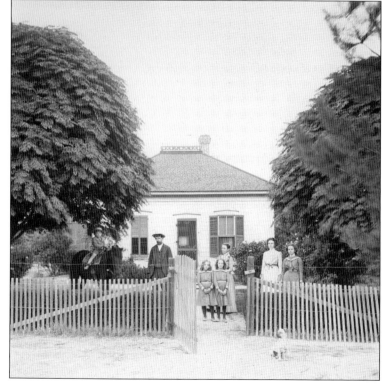

**MAYNARD MAPES HOME.** Built in 1890, the home of Maynard and Iona Mapes is located at 196 East Sixth Street in Perris. Shown with their children in front of the house are, from left to right, son Paul on the horse, Maynard, daughters Meta and Edith, Iona, and half sisters Grace and Lucy Kingston. The family occupied the house until 1986. The privately owned Mapes house, which is still standing today, has gone through several restorations over the years.

**Henry and Martha Lee Akin Family.** The Akins and their oldest son William arrived in Perris Valley by covered wagon from Los Angeles in 1882. They homesteaded a 160-acre quarter section at the northwest corner of Murrieta and Newport Roads. Planning on dry farming grain, Henry Akin worked tirelessly to make his farm a success. After several years of farming and having some bad luck with his crops in 1891, he decided to move his family to Perris. Taken in 1895, this photograph shows, from left to right, William, Wesley, baby Vernon, Martha, daughter Rena, and Elmer. Their youngest daughter Vera had not been born yet. Henry is not pictured.

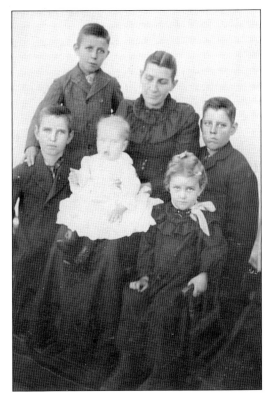

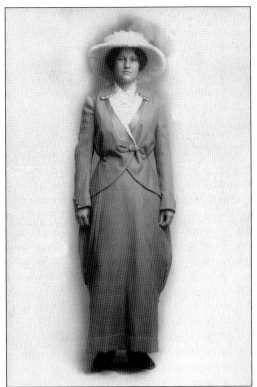

**Vera Akin.** The youngest daughter of Henry and Martha Akin was born in Perris on May 25, 1896. She outlived her entire family and passed away in Sun City, California, in 1995 at the age of 99. She was very involved in the Perris community her entire life. She helped run Moore's Meat Market in the Blue & White grocery store after her husband, Arthur Moore, passed away.

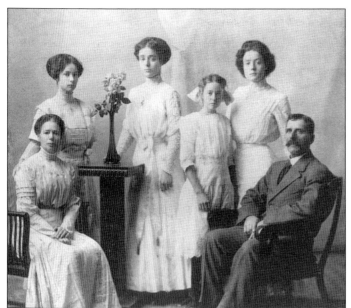

THE DUNSMOOR FAMILY. In 1894, Fred and Margaret "Maggie" Dunsmoor moved from Iowa to Perris with their children, Laura, Hazel, Bessie, and Mildred, and Fred's parents. The Dunsmoors were farmers in Iowa, and Fred continued to farm in Perris with his father and brother Abe. They purchased property on Eleventh Street with a house and five acres. They had many fruit trees and were especially proud of the orange orchard. Their daughter Mildred was the Perris city clerk for 20 years.

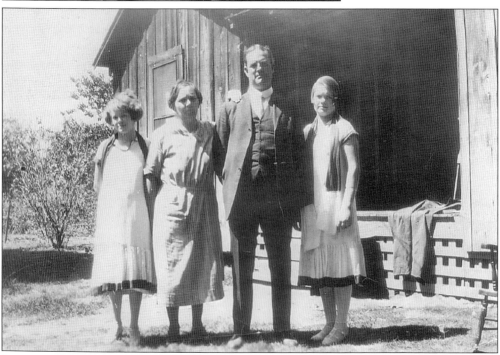

LEWIS AND LUCINDA HUNTER FAMILY. The Hunters are pictured here in 1925. From left to right are daughter Beulah, Lucinda, Lewis, and daughter Opal Hunter. Lewis worked as a well driller and a policeman, as well as at Mayer Farms in Perris, owned by Louis B. Mayer of the MGM movie studio. Lewis had a lifelong calling to be a minister, and after World War II, he was instrumental in moving a Camp Haan building to be used for the Woodcrest Community Church that he started. Beulah and Opal graduated from Perris Union High School and got married. Beulah had five children, and Opal had two children. Beulah's daughter Dixie and her husband, Floyd Heldorn, and some of their seven children are still living in the Perris Valley.

JOHN SR. AND MARIE LASSA COUDURES. John and Marie Coudures married in Riverside in 1915. Shown in this photograph are, from left to right, (first row) mother Marie, Louise, and father John Sr.; (second row) Marie, John Jr., and Denise. They lived and farmed sheep in the Alessandro area west of what is now March Reserve Base. They moved to Perris and purchased a 40-acre farm on Perris Boulevard in 1928. Over the years, they owned 5,000 acres and farmed 15,000 acres in the Perris Valley.

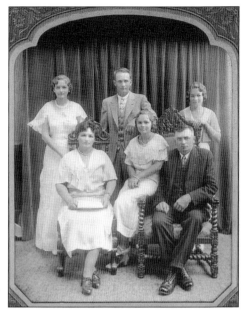

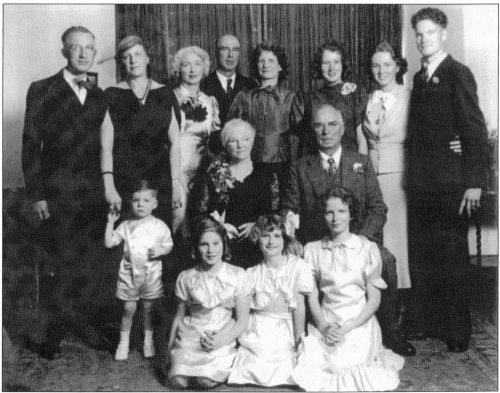

WILBERT AND KATHERINE STEWART. The Stewarts were owners of the Bank of Perris. They are shown in the center of this photograph on their 50th wedding anniversary in 1937. Pictured with them are, from left to right, (first row) grandchildren Glenn, Genevieve, Berta, and Katherine; (third row) son Cliff and wife Freda Stewart, daughter Genevieve, son Bert and wife Edna Stewart, daughter Corrine Stewart, and Leona and (grandson) Bill Stewart.

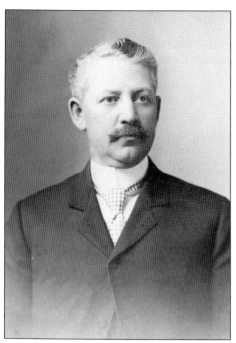

**ALBERT WALTER HOOK.** Albert W. Hook and his wife, Mabel, moved to Perris with his brother Joseph Hook in 1887. They were both merchants together in San Francisco and were looking for a property to acquire to start a new business venture in a warmer climate. After researching other areas, they decided Perris was a good location with the railroad running through the town. They purchased property on the northwest corner of D and Seventh Streets. With their business partner Ira Oaks, they built the Perris Valley Supply Company.

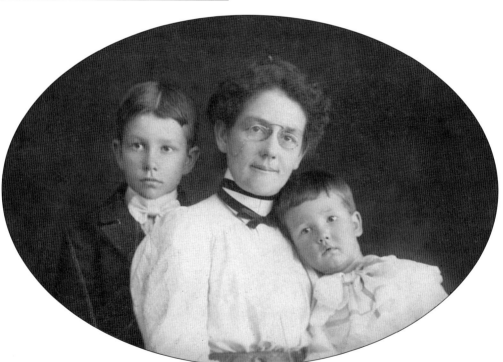

**MABEL MERRITT HOOK.** Mabel Hook, wife of Albert Hook, and their two sons Rufus, born in 1890, and Rolla, born in 1897, are pictured here in a sweet pose. Mabel came to Perris with her husband from San Francisco and enjoyed being part of the Perris society. Rufus stayed in Perris, where he took part in the Hook legacy of businesses, while Rolla moved away to Lake County, California, to take over his maternal grandparents' property.

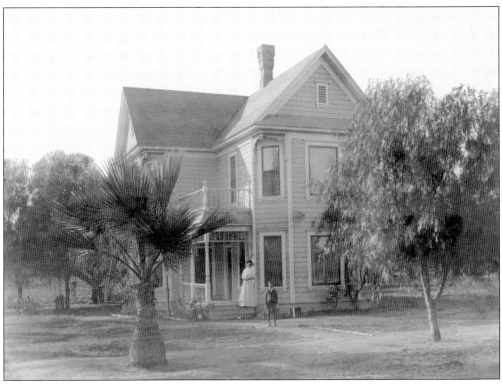

ALBERT W. HOOK HOUSE. Mabel and son Rolla are pictured in front of this 1891 Victorian beauty, home to four generations of the Hook family. It is located at 223 West Seventh Street in Perris and is one of the most historic homes still standing in the area. A member of the Hook family lived in the house until 2013, when Peggy Hook, wife of Rufus M. Hook, the grandson of Albert and Mabel Hook, passed away. The daughter of Rufus "Bud" and Peggy Hook now owns the house.

SANTA ROSA MINE. Rufus Merritt Hook is pictured with his wife, Cora Pet Hook, at the Santa Rosa Mine in the early 1920s. The mine is located along Santa Rosa Road in the Gavilan Hills area west of Perris. The Hooks were successful in mining gold at the Santa Rosa Mine, but it did not produce as much gold as the Good Hope Mine. Hook family members still own the mine property today, but it has been inactive and closed up for several decades.

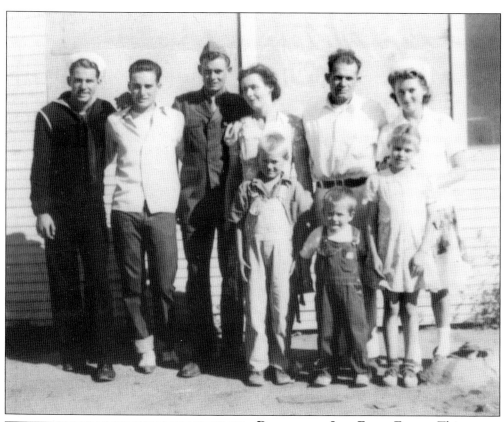

**Donald and Ival Evans Family.** This family is part of the pioneer Evans (Menifee-Perris) and Embertson (Lakeview) families. They are pictured here with their children in 1943. From left to right are (first row) Ronald Evans, Iral Evans, and Barbara Evans; (second row) Raymond Evans, Delbert Evans, mother Ival, father Donald Evans, and Grace Evans. Sons Raymond, Delbert, and Leon served in World War II. Both Raymond and Delbert were killed accidently in 1945. Iral Evans and his wife Joanne are very active members of the American Legion Post 595 in Perris. (Courtesy of Iral Evans.)

**Carlos and Evelyn Young Pico Family.** As a Luiseno Indian, Carlos grew up on the Pechanga Indian Reservation in Temecula and arrived in Perris in 1925. He married Evelyn Young, also part Luiseno Indian, and they had five children: daughters Germaine, Milless, and Marie, and twin sons Norman and Gabriel (pictured). All their children attended school in Perris. Both Carlos and Evelyn worked at Camp Haan during World War II.

**ALFONSE AND MARIE MOTTE FAMILY, EARLY 1920S.** The Mottes started out farming sheep in the Arlington area of Riverside, and in the 1920s, they moved to the Lakeview area. John and Frank Motte farmed with their father and became known as Motte & Sons in their farming and land acquisition enterprise, which amassed thousands of acres. From left to right are (first row) twins Charles and Charlotte; (second row) daughter Marie with sons John and Frank.

**RALPH KENNETH AND ANNA MARIE HUTTON RICKETTS.** Kenneth and Anna Ricketts were married in Perris on September 2, 1923. Their children were Elinor, Betty, and Edward. Several generations of the Ricketts family grew up in Perris and lived in Perris over the years. Betty Ricketts Golding still lives in Perris today. (Courtesy of Chuck Golding.)

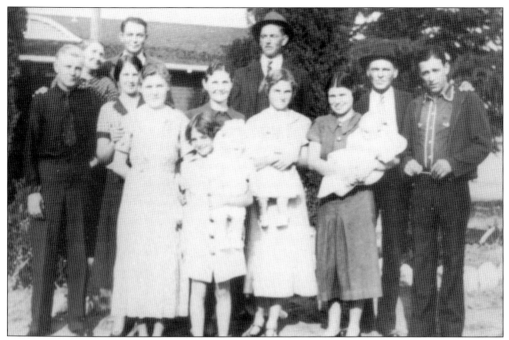

JOHN AND ALICE ASHLEY FAMILY. The Ashley family arrived in the Perris Valley in 1928 in a Model T, settling in Nuevo. Alice was a cook for the Nuevo School and took good care of her children. The older boys, John E. "Lucy" and Virgil, had arrived earlier by hopping on trains and walking. The children were all active in the Perris Valley community. Pictured are, from left to right, (first row) daughters Ottie Mae, Ethel (with her daughter Lois in front of her), Geraldine, and Jeanie (wife of J.E. Lucy Ashley); (second row) son Cotton with his wife Theda, mother Alice in back of Cotton, sons Virgil, J.E. Lucy, father John, and Ethel's husband Slivers. (Courtesy of Marion and Mary Ashley.)

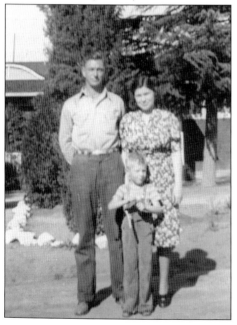

J.E. "LUCY" AND VIRGINIA ASHLEY. Lucy and Jeannie, as their friends and relatives called them, are pictured here with their son Marion. Lucy was one tough character. The rodeo star and trucker had his own potato shed and ran potatoes. Jeannie was a wonderful mother and school board member at the Romoland Elementary School. They had two sons, Marion and Mike. Marion excelled in sports and went to college to become a CPA, while Mike pursued real estate. Marion has been involved in many community activities most of his life and has served as the Fifth District supervisor for Riverside County since 2002. (Courtesy of Marion and Mary Ashley.)

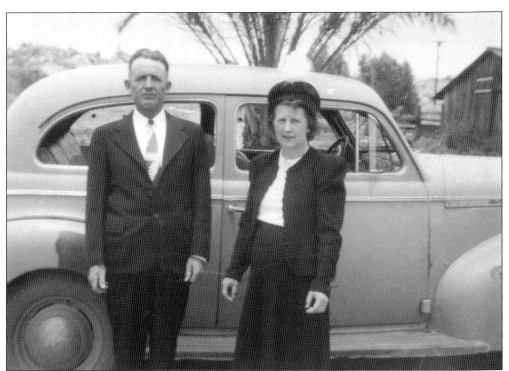

THOMAS AND MARGARET HANIFIN. After emigrating from Ireland, Tom and Margaret Brosnan Hanifin were married in Chicago in 1930. They moved to Perris in 1931 and raised a family of seven children. Margaret's uncle John Brosnan, a carpenter in Perris at the time, told them there were jobs in the Perris Valley during the Great Depression, when work was scarce. When they arrived, Tom got a job working on the Mitchler Ranch in the north Perris area. In 1942, they purchased a house with nine acres and had their own small farm. Tom worked for the Perris Valley Cemetery District for 24 years until his death in 1964.

HANIFIN FAMILY. The seven children of Tom and Margaret Hanifin were very much involved in working on their parents' nine-acre farm on Park Avenue. They helped with the growing and packing of the vegetables that were sold to the local grocery stores, and the watermelons that were sold to larger markets like Safeway. They participated in many community clubs and events. All the children attended the Perris schools and graduated from Perris Union High School. From left to right are (first row) daughters Eileen, Katie, and Betty; (second row) their only son John and daughters Peggy, Mary, and Josephine.

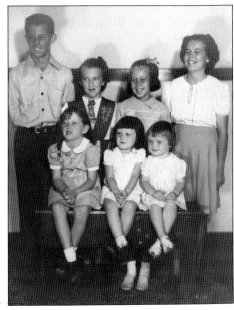

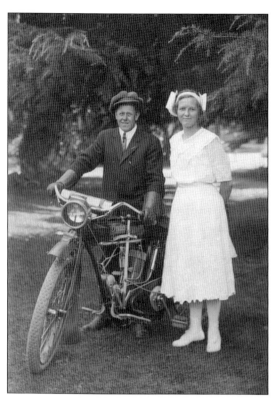

**NORMAN AND AGNES WALKER.** Norman arrived in the northeast area of Perris Valley to what was then known as Nuevo Gardens in 1914. He started with 50 acres along Lakeview Avenue, and in 1916, he married Agnes Alumbaugh. They are posing with an Indian motorcycle in this photograph. They had gone to high school together in Santa Ana and soon built a home on their Lakeview Avenue property, where they raised four children: Clarence, Bob, Gaye, and Mary Ann. Active in farming, Norman helped to establish the Perris Valley Farm Bureau and Nuevo Lakeview Grange. Agnes was involved in the PTA, along with many other activities related to raising their children.

**LLOYD AND EVELYN VOSS MCCALL.** Married in 1944, Lloyd and Evelyn McCall had three children: Gary, Gregg, and Janice. Evelyn became a teacher and taught at Perris Elementary School from 1946 to 1948 and Romoland School from 1955 to 1965. Evelyn's parents, Dean and Helen Voss, were farmers in Perris. Lloyd was the son of Fred and Leila McCall, a farming family in the Menifee area. Lloyd was on the Perris Union High School board in the 1960s. With his twin brother, Floyd, and brother-in-law Art Crom, Lloyd was an owner in the McCrometer Company based in Hemet that made water meters. McCall Boulevard in Sun City is named for his father, who was a Riverside County supervisor at the time.

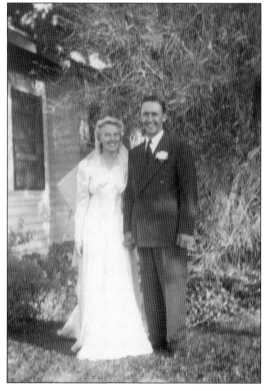

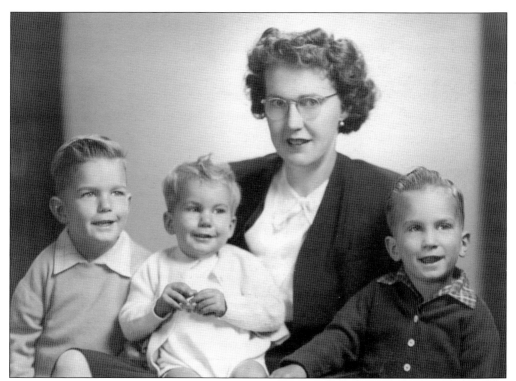

**Dr. Ann Parker Family.** In 1944, Dr. Ann Parker came to Perris with her husband, Dr. Bill Parker, to set up a medical office. They took over the practice of Dr. Jones, which was located on D Street under the Perris Hotel. Their office remained there until Bill became ill, at which point Ann went to work for Riverside County as a doctor in the social services department. She is pictured with her sons, from left to right, Tom, Henry, and Peter, in this 1945 photograph.

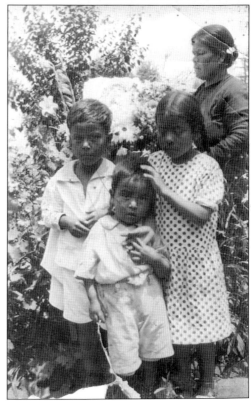

**Manuel and Francisca Villalovos Family.** Francisca Villalovos is pictured with her three children, daughter Hazel and sons Manuel and Frank. Manuel and Francisca traveled from Uruapan, Michoacan, Mexico, in 1922 and settled in Riverside. They moved to Perris in 1928; unfortunately, Manuel passed away in 1931. Francisca raised their children, who all attended Perris schools. Hazel married Pete Pacheco and they had 13 children, Manuel and his wife Jessie had two daughters, and Frank and his wife Gloria had four children. (Courtesy of Linda Pacheco Weeks.)

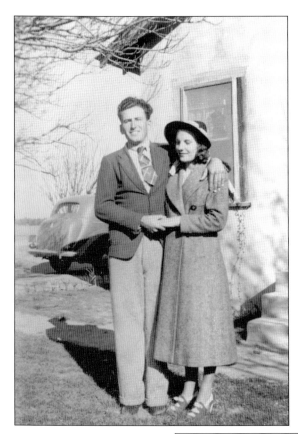

**ROY AND MARY ANNAH ASHLEY SMITH.** Roy Smith, of the large John Smith Sr. farming family of Nuevo, married Mary Annah Ashley in 1938. They had three children: a daughter Ramona and sons David and Larry. Roy continued to farm on land in the Perris Valley. His crops consisted mainly of alfalfa, potatoes, grain, and sugar beets.

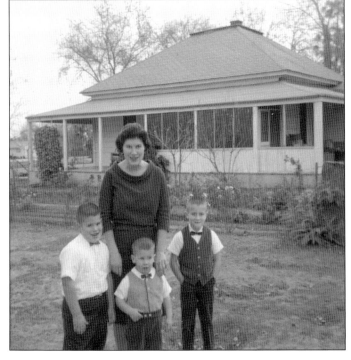

**RALPH AND LOIS STENLAKE FAMILY.** The Stenlake family lived in the house shown here that was once the Robertine Hotel on the southwest corner of Fifth and C Streets. Ralph Stenlake, not pictured, was a teacher and coach at the Perris Junior High School for 40 years. Lois Stenlake is shown with her boys (from left to right) Steve, David, and Earl. (Courtesy of Steve Stenlake.)

## Four
# THE MID-CENTURY

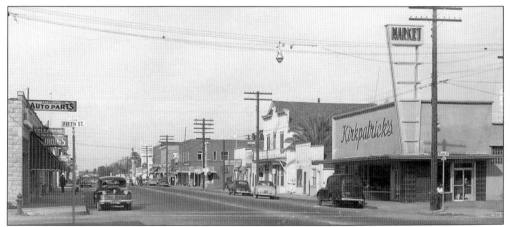

DOWNTOWN PERRIS, 1950. Pictured here is the newly built Kirkpatrick's Market on the southeast side of D Street. After World War II, new housing developments were built north of downtown, (Rancho Village), and in south Perris (Perriscito Tract). Many Perris families were excited to have new houses to move into. Several of the new houses were occupied by military families stationed at March Air Force Base. The population at the time was approximately 1,800 and grew over the next few years to 2,700. Perris was a small, quaint town and a great place to live and raise a family.

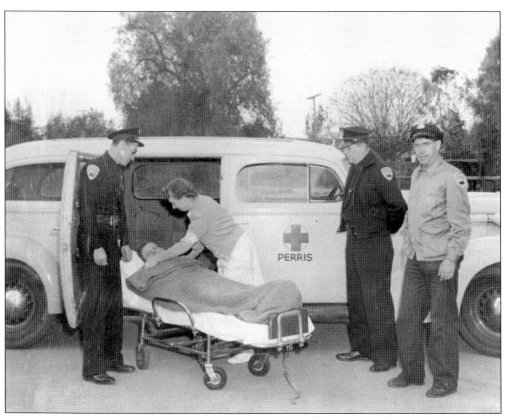

**PERRIS POLICE DEPARTMENT, 1950s.** Nurse Grace Reid, wife of longtime Perris doctor Robert Reid, is shown readying a patient for ambulance transport, with the help of police officers (from left to right) Bill Ball, Burt Broesamle, and Frank Kitchen. The officers of the day were friendly and helpful to the citizens of Perris and looked out for children.

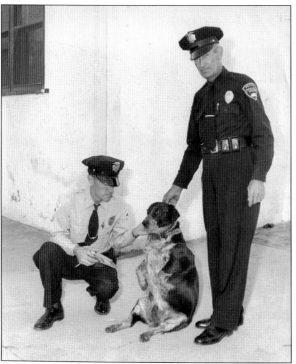

**PERRIS POLICE OFFICERS WITH MAN'S BEST FRIEND.** Police officers Bill Ball (left) and Frank Kitchen are pictured with their faithful friend. Perris did not have trained police dogs in the 1950s but these officers enjoyed having this dog with them. The police station was located at the southwest corner of Fifth and D Streets, next to Perris City Hall.

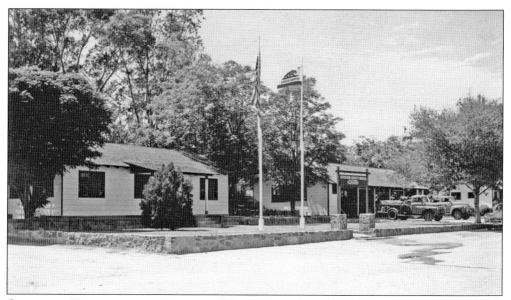

CALIFORNIA DEPARTMENT OF FORESTRY. The CDF was located at the northwest corner of San Jacinto Avenue and C Street in Perris, as seen in this 1950s photograph. The land was leased to the state in 1932, and the CDF headquarters was later built there. It also became the headquarters for the Riverside County Fire Department, which was known as Facility No. 1. It is still located there today. Ed Nelander Sr. was the first ranger unit chief.

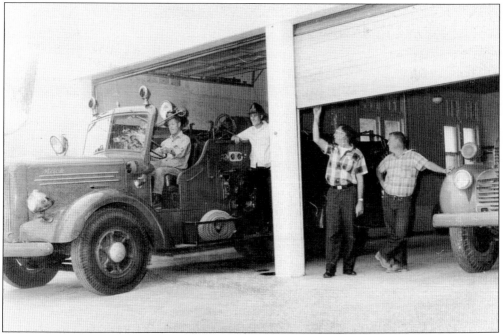

PERRIS VOLUNTEER FIRE DEPARTMENT, 1950s. The city of Perris was protected by an all-volunteer fire department. It was located with the city hall and jail at Fifth and D Streets. In the early days, the only fire alarm was the telephone operators going outside their office on D Street and ringing a loud bell. Besides waking up the volunteers, it would wake up most of the town. From left to right are Bill Hare, Carl Porter, fire chief Ed Nelander, and Joe Porter.

**Perris Boy Scout Troop 40.** Members of the Perris Boy Scout Troop 40 pose for a picture at the summit of Kaiser Pass in the Sierra Nevada Mountains while on a camping trip to Lake Florence in 1949. From left to right are (seated) Maynard Small, Bruce Cowie, Windslow Small, Jan Berlin, Mickey Butchko, Glenn Stewart, and Damon Kirkpatrick; (standing) leader Earl Squires, Roger Honberger, Bill Nickeral, Dean Bleer, leader Slim Cowie, Glenn Spencer, and leader Francis Honberger.

**Perris Cub Scouts.** These Cub Scouts are pictured with their leaders in the early 1950s. From left to right are (first row) Bill Anderson and Rodney Williams; (second row) two unidentified, David Butchko, Bobby Johnson, Denny Scott, Robert Sanders, Manson Merritt, Val Reynolds, and Mark Saunders; (third row) leader Nan Sanders, Mickey Butchko, Silverio Espinoza, and Opal Merritt.

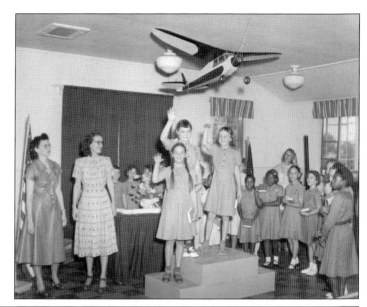

**PERRIS BROWNIE TROOP.** The Brownie Flying Up ceremony is an integral part of advancing to Junior Girl Scouts. This photograph shows the girls going through the process. From left to right are leader Hilda Allee and Peggy Fox; (on the stand) Jeanne Martin, Ramona Allee, and Carolyn Fox; (standing in the background) unidentified, Barbara Bonner, Pauline Thomas, Mary Butchko, Pam Scott, two unidentified, and Betty Jean Love.

**BROWNIES IN NEW GIRL SCOUT HOUSE.** In 1953, a new Girl Scout house was built in Perris with the strong support of the community and the Lions Club of Perris. Leader Peggy Hook, in front, talks to her Brownie troop. From left to right are (first row) Pauline Jackson, Karen Heidanus, Donna Pettit, Christy Hook, and Monica Duden; (second row) unidentified, Iris Grewing, Pam Donaldson, Diane Pettit, Janice Martin, Eileen Beeson, Cheryl Zack, and Susan Randolph; (third row) unidentified, Arlene Wrigley, unidentified, Georgina Davis, Wincie Gardner, Cathy Calhoun, Anna Jean Smith, unidentified, and Helen Beeson.

**ELSINORE-PERRIS ORDER OF DEMOLAY CEREMONY.** The Elsinore-Perris DeMolay Installation Dinner of 1957 was held in the Perris Masonic Temple. From left to right are Keith Stewart, Denton Cooper, and Tom Parker. The combined chapter met in the old Evelyn Hall building on D Street in Perris for many years. The building was also used for Masonic meetings.

**JOB'S DAUGHTERS CEREMONY.** Perris has always been supportive of youth and adult organizations and, for many years, had an active Mason presence in Perris. This group photograph of a Job's Daughters ceremony at Evelyn Hall in Perris shows an impressive group of young women in the early 1960s.

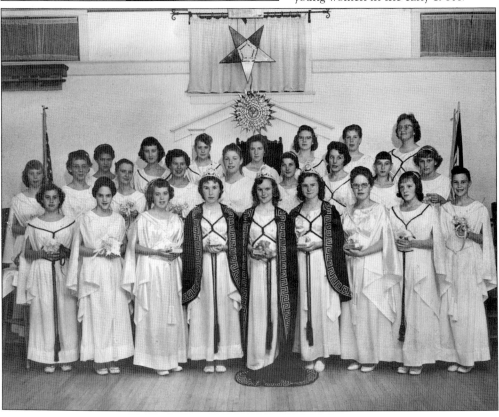

**Perris Panthers 4-H Club.** In 1954, one of the most outstanding 4-H Clubs in Riverside County was founded by two remarkable people, Johnny Harrison and Nan Sanders. They started out with seven boys, and it grew tenfold over the years. Both Harrison and Sanders were youth-oriented leaders who enriched the 4-H members' lives by teaching responsibility and leadership. Harrison was involved in the Junior Livestock Auction at the Farmers Fair (now known as the Southern California Fair). Sanders was a Perris school board member for more than 50 years, and the Nan Sanders Elementary School was named for her dedication to the children of Perris Valley.

**Fair Time for Perris Panthers 4-H Club.** When fair time came around, it was exciting for the 4-H members to take their animals to the Farmers Fair in Hemet to have them judged and sold at the Junior Livestock Auction. In 1960, Perris Panthers members are shown helping each other get this project steer ready for show. From left to right are Alan Young, Donna Smith, Katie Hanifin, and Dean Clark. In the background at right is David Smith working on his steer.

PERRIS ELEMENTARY SCHOOL BAND. Band instructor and teacher Leland Scott is shown standing on the left with his impressive Perris Elementary School Band in 1957. Scott's professionalism and love of music inspired many students to learn to play instruments. The band represented Perris in many parades, both in Perris and out of town. Scott taught at the school for 47 years before retiring.

PERRIS TRUMPET AND DRUM CORPS. In 1949, the Perris Elementary Trumpet and Drum Corps was organized by principal James Hoadley after he started a music program. Shown playing at a flag-raising ceremony are, from left to right, Pete Fraley on the drum, Warren Bergren, Maynard Small, Roger Honberger, Bruce Cowie, Gary Raymond, and Don Imus of New York radio fame. (Courtesy of Roger Honberger.)

**LITTLE LEAGUE IN PERRIS.** Darrell Smith (left) and his cousin David Smith are ready to play ball in 1956 on the opening day of the newly formed Perris Little League. The city of Perris has always supported youth programs and has many parks and ball fields today. (Courtesy of Larry Smith.)

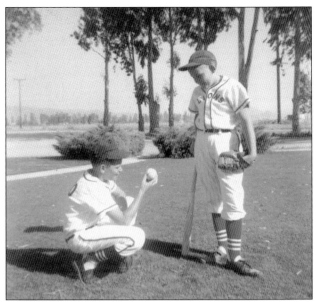

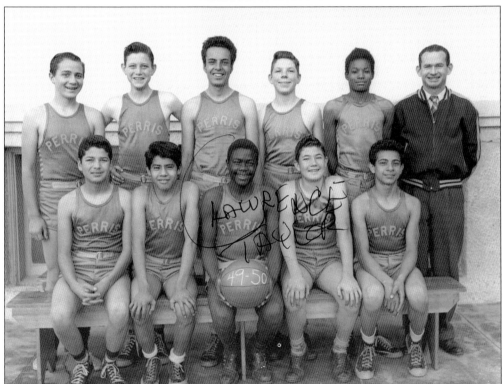

**PERRIS ELEMENTARY SCHOOL SEVENTH GRADE BASKETBALL.** This group of seventh graders formed the first ever basketball team for the Perris Elementary School Bears in 1948. They even won a tournament against Romoland, Nuevo, Lakeview, Val Verde, Menifee, and Winchester. From left to right are (first row) Vincent Del Rio, Tony Moreno, Lawrence Taylor, Roger Honberger, and George Ortiz; (second row) Maynard Small, Roy Daniels, Mario Espinoza, Glenn Stewart, Tom Wilson, and Coach McHenry. (Courtesy of Roger Honberger.)

FIRST CONGREGATIONAL CHURCH CHOIR. The children's choir of 1966 was most impressive. From left to right are (first row) Linda Westbrook, Teresa Perrine, Debbie Markley, Sharon Zieders, Laurie Williams, and Lance and Lane Laubscher; (second row) Vi Brosamle, Debbie McNitt, Roxanna Sanders, Jeannie Rusher, Anita Huff, Alice Kirkpatrick, unidentified, and Chris Clark; (third row) Jo Reed, Mary Willis, Star Clark, Nancy Reed, Allen Westbrook, Joanne Sawyer, and Pam Cochran. (Courtesy of the First Congregational Church.)

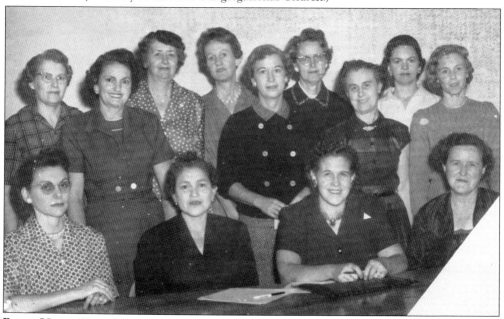

PERRIS UNION HIGH SCHOOL PTA. These dedicated women were very involved with helping the students and the school in the 1950s. From left to right are (first row) Hilda Allee, Esther Gonzales, Nan Sanders, and Mrs. Lowe; (second row) Mrs. Weid, Mrs. Hamner, Elva Anderson, and Helen Beeson; (third row) Mrs. Pettit, Lois Purtteman, Mae Berlin, Mrs. Northrup, and Mrs. O'Blenness. Many of these women were also scout leaders, civic leaders, and community volunteers.

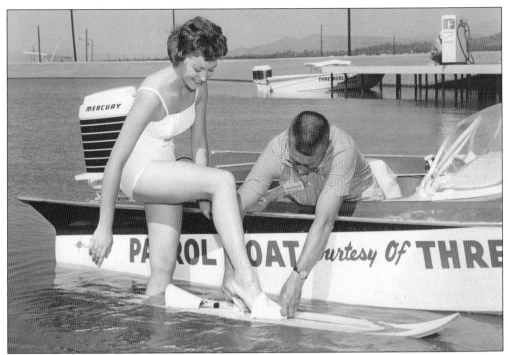

WATER RECREATION AT SKI-LAND. Denise Parker, Miss Perris 1960, is shown getting some help putting on a water ski. Powerboats and waterskiing were allowed in this water recreation area, which included private beaches, camping sites, picnic tables, sunshades, and a snack bar. Many locals and out-of-town visitors came here for fun.

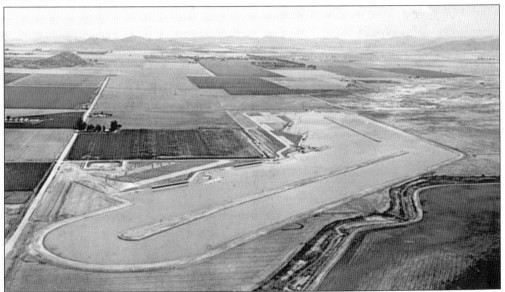

SKI-LAND PERRIS. In the late 1950s, a man-made water recreation area was built on San Jacinto Avenue east of Perris, near Nuevo. It was the home of the National Drag Boat Association. Semiannual drag boat races were held, and world speed records were established at some of the races. It stayed active through most of the 1960s before shutting down. Today, it is owned by Eastern Water Municipal Water District and used as a reclamation facility.

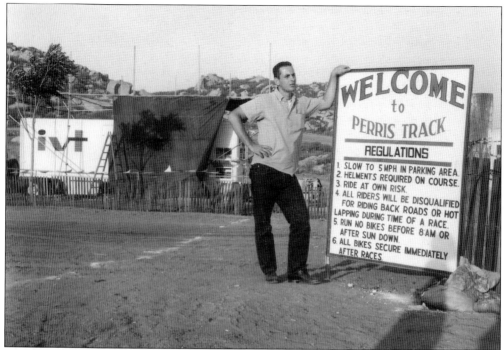

PERRIS MOTORCYCLE TRACK. Gerry Burton and his wife, Alice, built the Perris Motorcycle Track in the early 1950s. Located off Ellis Avenue on Burton Road west of Perris, the track was an exciting place to go for fun and entertainment. In the beginning, flat track racing was the rage. Later, when newer motorcycles were popular, it became a motocross track. It is still in operation today under new ownership.

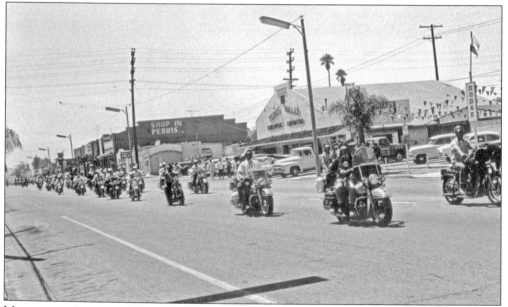

MOTORCYCLE PARADE IN PERRIS. With the popularity of motorcycles, the Perris Motorcycle Track was used to film the movie On Any Sunday and held major motorcycle races in the 1960s. To celebrate, the ABC's Wide World of Sports held a parade and filmed the race.

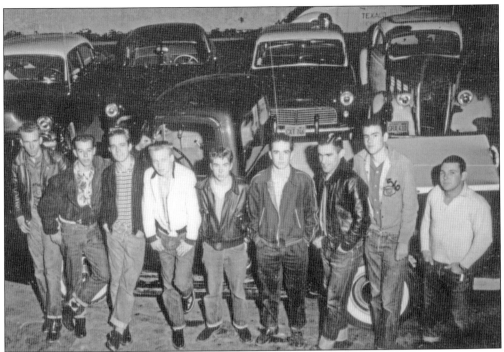

UNDERTAKERS CAR CLUB. In the early 1950s, the Undertakers Car Club was formed by several young men in the Perris Valley. Roland Sanders, who ran the Texaco station in Perris, was their sponsor. One of the things they did for the public was to help people with car trouble along the roads. Sanders received many thank-you notes for the good deeds of the club members. From left to right are Pete Fraley, Gary Raymond, John Chappell, Robert Perrine, Mike Beatty, Bob Jensen, their advisor Robert Wilson, Bob Gordon, and George Magno.

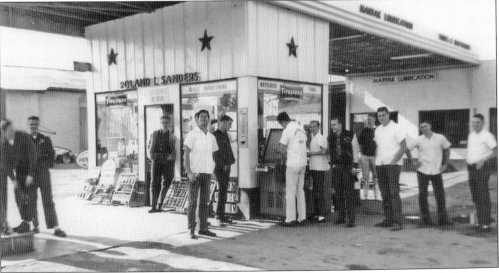

TEXACO SERVICE STATION. In the late 1950s and early 1960s, the Texaco station was the hangout for the Undertakers Car Club. Roland Sanders, the club's sponsor, would often get calls from the members' mothers to send them home for dinner. The club is still active today and participates in the Rods & Rails event in Perris.

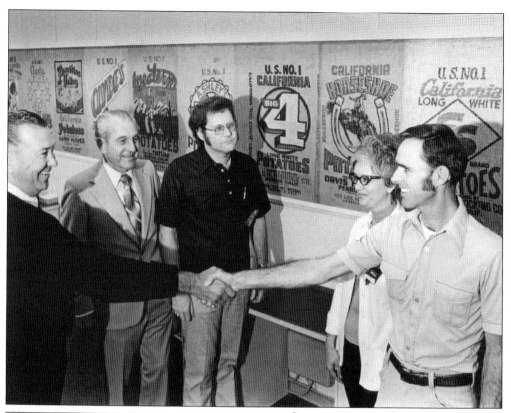

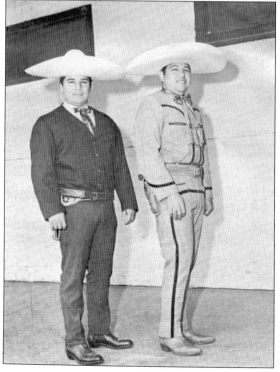

SECURITY PACIFIC BANK. Shown at the Security Pacific Bank in the early 1960s are, from left to right, Norman Hughes, bank manager Louie Boettcher, Danny Davis, unidentified, and Jack Eels. In the background, note the potato sacks with brands from local potato farmers that were used as wall decor. When the bank redecorated a few years later, the potato sacks were given to the Perris Valley Historical Museum for safekeeping.

CINCO DE MAYO. For many years, the city of Perris celebrated Cinco de Mayo with a parade and festivities. Here, Louie (left) and Benny Villegas, from a longtime pioneer family, are dressed up and ready to have a good time in 1968. They were instrumental in planning and organizing the parade. (Courtesy of Benny Villegas.)

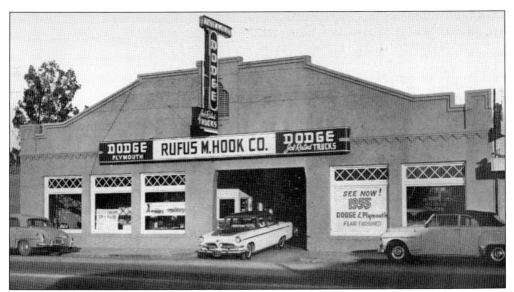

Rufus M. Hook Co. After returning from World War II, Rufus "Bud" Hook Jr. took over the Perris Garage and car dealership from his father. He continued to sell Dodge and Chrysler cars, along with offering maintenance and repairs. Bud, like his father, was an honest and principled businessman. He had many faithful returning customers. Bud passed away in 1983 and left a Hook family legacy in Perris.

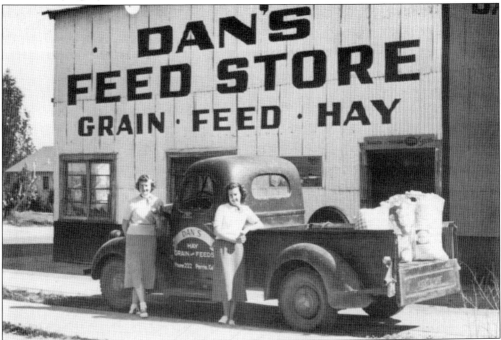

Dan's Feed & Seed. Dan Holzer was the original owner of Dan's Feed & Seed, which has been in business for over 75 years. In the 1950s, it was sold to Johnny Harrison and Johnny Kolb, and a few years later, Harrison took sole ownership. Pictured here is the old location on the southeast corner of Perris Boulevard and Third Street. The store moved to a new location on Fourth Street in the 1970s.

ROTARY CLUB OF PERRIS. This is one of the most active organizations in Perris Valley. Several hardworking members are pictured at their annual pancake breakfast fundraiser in the late 1960s. The tradition continued for more than a decade. From left to right are Dr. Richard Blowers, Bob Walker, Howard Schlundt, Johnny Harrison, Louis Boettcher, and John Brown.

JOINT COLOR GUARD. On January 25, 1997, Fred T. Perris Day was held at the Perris Santa Fe depot and Perris Valley Historical Museum. A joint color guard from the American Legion Post 595 and Veterans of Foreign Wars 888 stands for the flag salute. From left to right are Ray Balboa, Ken Ruport, Joanne Evans, Dave Zelenka, Dutch Dittinger, Don Simpson, and Ernie Pacheco. (Courtesy of Iral Evans.)

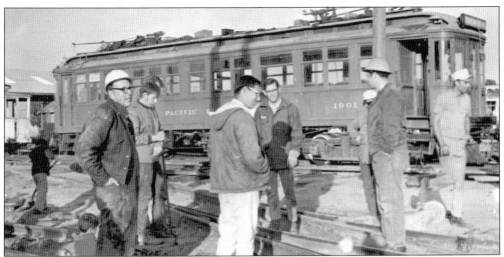

ORANGE EMPIRE RAILWAY MUSEUM. Originally known as the Orange Empire Trolley Museum, the railway museum was moved to its permanent home in Perris in 1958. Hauling historic streetcars to 2201 South A Street and laying track occupied these rail enthusiasts for many years. From left to right in front are Ben Minnich, Bill Bauer, and Paul Dieges. The remaining members are from the Los Angeles area.

SANTA FE RAILROAD DEPOT. The Perris depot is one of the most elegant of the nation's few surviving small-town railroad depots. In 1971, the Santa Fe Railroad donated the Victorian station to the Orange Empire Railway Museum (OERM). Shown at the ceremony are, from left to right, Riverside County supervisor Norton Younglove, city councilman Ben Minnich, OERM officer Ed Von Nordeck, Santa Fe vice president Lawrence Cena, OERM officer Bob Hulstrom, and other Santa Fe officials. Cena grew up in Nuevo, California, attended Perris Union High School, and later became the president of Santa Fe Railroad.

CLARENCE MUSE. Songwriter, stage actor, and screen star Clarence Muse, shown at the golden anniversary of Perris, was involved in the community when he lived here from the 1950s until he passed away in 1979. His dedication to Perris has left his legacy as the founder, with the help of others, of the Perris Valley Arts Festival and Christmas Hollow, a program to give gifts to the children of Perris. He was inducted into the Black Filmmakers Hall of Fame in 1973. Muse was one of the founding board members of the Perris Valley Historical & Museum Association.

CLARENCE MUSE WITH PERRIS CHILDREN. Muse's love of children shows in this photograph. He is pictured with his good friend Robert Warren's children Janet (far left), Tommy (second from left), and Bobby (second from right), and his friends Todd (front right) and Scott Parker (far right) at his home on the Muse a While Ranch. After church on Sunday, Warren would often visit with Muse and his wife. (Courtesy of Tom and Midgie Parker.)

**GOLDEN ANNIVERSARY OF THE CITY OF PERRIS.** Perris mayor Robert Warren (left) and chamber of commerce president Jack Savage welcome visitors to the Old Timers Day celebration in 1961. While Mayor Warren was in office, he was one of the leading forces in forming the Perris Valley Historical & Museum Association.

**FIRST MUSEUM BOARD MEMBERS.** The Perris Valley Historical & Museum Association was chartered on February 17, 1964. From left to right are Ted Zschokke, Oliver K. Young, Leonard Kirkpatrick Sr., Hazel Youngstrom, and Mildred Martin. Not pictured are Robert Warren and Clarence Muse. The museum moved to its present location in 1974. Today, it is one of the strongest all-volunteer museums in Riverside County.

**NORMAN HUGHES.** Pictured at the Perris Valley Airport, Norman Hughes's daughters, (from left to right) Robin, Kathy, and Terry, are all dressed up and ready to take a flight with their dad. Hughes was a pilot in World War II and enjoyed having an airplane. He frequently flew around the valley with his friend Bob Ashley. He had many humorous stories about his trips. (Courtesy of the Norman Hughes family.)

**FRAN'S FASHION SHOP.** Fran Underwood is shown displaying a dress to a customer in her shop. She opened Fran's Fashion Shop in Perris in 1959. Fran's offered high-quality clothing and merchandise, which saved many Perris Valley women from going out of town to shop. Underwood was a wonderful businesswoman who worked hard to please her customers.

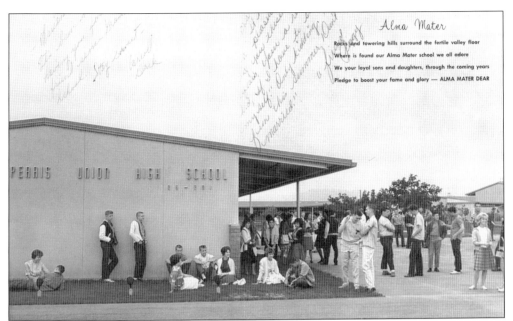

**NEW PERRIS UNION HIGH SCHOOL.** In 1961, the Perris Union High School District built a new high school, shown here with students, on the southeast corner of Perris Boulevard and Nuevo Road. The campus has been expanded several times. To keep up with the continued growth, two other high schools were established, Paloma Valley High School and Heritage High School, both located in the Menifee area.

**JUNIOR CLASS OFFICERS.** The growing and diverse student body at Perris Union High School reflects the junior class motto "Freedom of 'Spirit'" in 1974. The class officers shown are, from left to right, (first row) Sheila Arnold, treasurer; and Lori Von Nordeck, president; (second row) Robert Vivian, vice president; and Vickie Wilson, secretary.

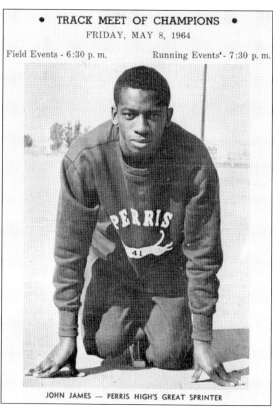

**JOHNNIE JAMES.** Perris Union High School track star Johnnie James broke running records at the school and went to the California State Championship. He is pictured here in 1964, ready to take off. (Courtesy of Johnnie and Jeanie James.)

**SPORTS MEDICINE.** In the 1950s and 1960s, Dr. Ann Parker served as the doctor for Perris Union High School sports teams. Here she is shown giving a flu shot to Jack Eels. Among the others in the photograph are Duane Cress, Jimmy Sims, Jeff Stewart, and Billy Butchko. (Courtesy of Tom Parker.)

## Five

# MODERN TIMES

DOWNTOWN PERRIS, 2010. The City of Perris has been revitalizing the downtown area for the past several years. This photograph shows a view of D Street looking north between Third and Fourth Streets. With new sidewalks, trees, and building facades, Perris is looking like quite the beautiful city. Growth in Perris has exploded over the past 30 years, and today, the population is nearing 84,000 people. Perris is full of great venues and museums, as well as popular attractions like Lake Perris, the Southern California Fair, Perris Speedway, Skydive Perris, Drop Zone Water Park, and Big League Dreams.

CITY OF PERRIS CIVIC CENTER. The former Perris Union High School administration and classroom buildings have been completely restored. The administration building is seen as it appears today. It was originally built in 1932, along with a gymnasium that is used by the City of Perris Department of Community Services.

CITY OF PERRIS COUNCIL CHAMBERS. The city council chambers were originally built as classrooms and a library for the Perris Union High School in 1910. When a new high school was constructed in 1961, the building was vacated and later purchased by the City of Perris. In 1932, a furnace fire destroyed the west portion of the building, and it was never rebuilt. It was used by the Perris Police Department for several years, and in 2007, it was restored for the city council chambers.

PERRIS VALLEY AIRPORT. Originally dedicated in 1933, the Perris Airport has become one of the most important venues in Perris. In addition to its use for private planes and crop dusters, the airport is an internationally renowned skydiving center under the ownership of the Conatser family. Skydive Perris has broken many skydiving records and has raised hundreds of thousands of dollars for charity. Its newest attraction is a wind tunnel skydiving simulator, which is very popular. (Courtesy of Skydive Perris.)

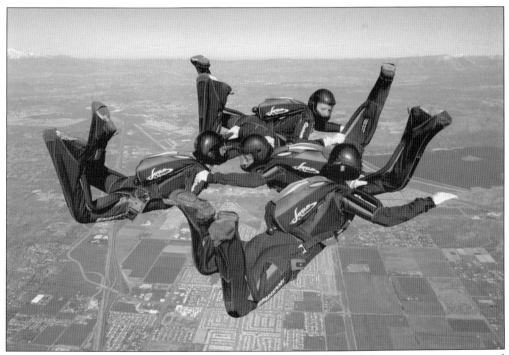

INTERNATIONAL TEAM AT SKYDIVE PERRIS. The Skydive Perris facility is host to many international skydiving teams from all over the world. Shown here is the French women's team. The Bombshelter Restaurant & Bar is located on-site for dining and entertainment, including watching the skydivers. Note Lake Perris in the background of the landscape below. (Courtesy of Skydive Perris.)

SOUTHERN CALIFORNIA FAIR. The original Southern California Fair began in Riverside in 1913 and evolved into the Turkey Show and then the Farmers Fair as part of the state's 46th Agricultural District. It was located in Hemet for 50 years until a larger area was needed. In 1987, the fair was moved to property belonging to the State of California next to Lake Perris. It continues to grow every year and has many exhibits, including livestock, home arts, fine arts, photography, and collections, just to name a few. In 2013, the fair celebrated its 100th anniversary, and the Perris Valley Historical Museum created a display for the event, a portion of which is seen here. (Courtesy of Dan Yost.)

PERRIS AUTO SPEEDWAY. Located at the Southern California Fairgrounds, the Perris Auto Speedway is one of the finest of its kind. The racing season runs from February through November, with sprint cars and stock cars, among others. People come from all over the country to participate in or attend the races. Ronnie Everhart, from Perris, is pictured with her No. 17 street stock racer. She is known as the "Racing Grandmother" and is an announcer at the track. (Courtesy of Doug Allen.)

ORANGE EMPIRE RAILWAY MUSEUM. This museum has built itself up from a small trolley museum in 1958 to the largest railroad museum in the western United States. It has thousands of visitors every year and puts on several special events. The most popular event is Thomas the Train, which comes to the museum every November to the delight of children. In addition to a steampunk festival, the museum hosts a Bunny Train, Pumpkin Train, and Santa Train every year during these holidays. It is open every day to visit and ride the trains.

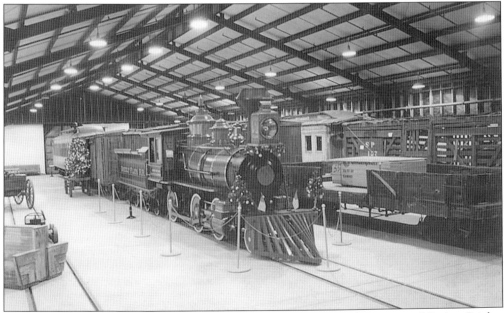

WARD KIMBALL COLLECTION. Ward Kimball of Disney fame was the creator of Jiminy Cricket and other characters. He donated his Grizzly Flats train collection to the Orange Empire Railway Museum. It is housed in a decorative building specially made for his collection. Kimball was a big fan of the museum. (Courtesy of the Orange Empire Railway Museum.)

PERRIS DEPOT RESTORATION. An enormous effort was made by the Orange Empire Railway Museum to obtain a grant to repair this historic depot. In reality, the structure needed substantially more restoration than what the grant could cover. With OERM and the Perris Valley Historical Museum both asking for help, the City of Perris stepped in to save this important Victorian depot in 2004. The depot was completely restored to its original glory at a cost of nearly $1.5 million. Dave Stuart, an extremely capable Perris resident, was hired as the project manager. It was a huge undertaking, as seen here.

PERRIS SANTA FE DEPOT DEDICATION. Lloyd Higginson, the last stationmaster for the Perris depot, is shown cutting the ribbon at the dedication ceremony on October 30, 2008. He was honored for his years of service to Perris. Higginson often worked 24 hours a day during the busy shipping season of the potato harvest. From left to right are (first row) John Higginson, Riverside County supervisor Marion Ashley, councilman Mark Yarbrough, Lloyd's daughter Dorene, Lloyd and his wife, and councilwoman Rita Rogers; (second row) Mayor Daryl Busch and councilman John Motte.

PERRIS HISTORICAL MUSEUM GRAND REOPENING. On January 31, 2009, a much-anticipated day finally arrived when a large crowd including television filmmaker Huell Howser came to Perris to make a documentary on the redevelopment projects in town. It was a festive day for all those attending.

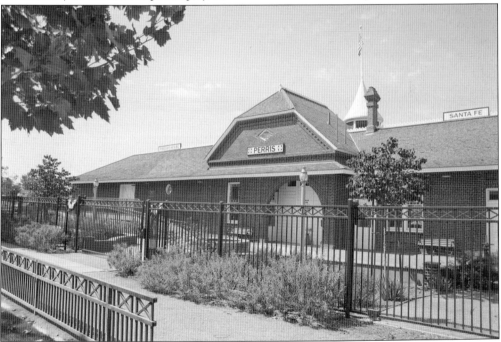

HISTORIC PERRIS SANTA FE DEPOT. Finally completed, the charming and inviting Victorian depot reopened with the newly designed museum inside. With the visionary concepts of Midgie Parker and the Native American exhibit created by Paul J. Price, the volunteers of the Perris Valley Historical Museum were very proud of their accomplishments. The Perris Valley Historical Museum is grateful to the City of Perris and the Orange Empire Railway Museum for saving this important historic treasure.

**ALBERTA MABEL AND CHARLES KEARNEY.** Pictured is Alberta Mable and Charles Kearney. In the late 1950s, the Kearneys moved to the Good Hope area of Perris and later into the town of Perris to a home they purchased on East Seventh Street, where they raised 11 children. Alberta was very involved in many community and civic activities and was the founder of the Dora Nelson African American Art & History Museum. Charles passed away a few years ago and Alberta passed away at the age of 95 in September 2016.

**DORA NELSON AFRICAN AMERICAN HISTORY MUSEUM.** According to Alberta Mable Kearney, she had been admiring the door of an old house, then found out that the city was going to demolish the building. She asked if she could do it, and paid $35 for the building. After demolition, she learned that it was the First Baptist Church started by Dora Nelson, an early African American pioneer. She was very dismayed by the fact that she had torn down the church. To atone for what she had done, she started a museum in Dora Nelson's honor. It is the only African American museum in the Inland Empire.

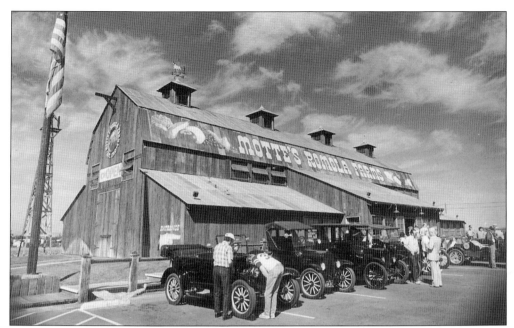

MOTTE HISTORICAL MUSEUM. Leon and Darlene Motte built this attractive barn in 1989. Architect Robert Morris repurposed old barn wood to construct the building. It was used as a produce market for many years. In 2010, Leon and his brother John partnered to build a museum to house their family's antique and classic car collection. They have included history of their farming roots and Perris Valley using copies of panels that were produced by the Perris Valley Historical Museum for the city of Perris's centennial exhibition. (Courtesy of the Motte Historical Museum.)

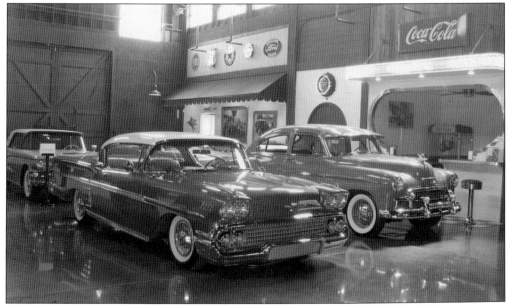

INSIDE MOTTE MUSEUM. The interior of the museum is nothing but spectacular. Many beautifully restored vehicles are displayed, along with attractive vintage decor. The museum is used as a venue for weddings and private parties. Pictured are Leon Motte's original 1958 Chevy Impala and Alice Ashley's 1950 Chevrolet.

**RODS & RAILS.** One of the major events the City of Perris has sponsored since 2000 is Rods & Rails, a car and motorcycle show with two stages for entertainment. Bruce Cooper, a former Perris resident, has completely restored this beautiful 1917 Model T flatbed truck. It was originally used as a delivery truck for the Holloway Hardware store in Perris about 100 years ago. He has won many trophies with his truck. (Courtesy of the City of Perris.)

**POTATO FESTIVAL.** As part of the city of Perris's Rods & Rails event, the Perris Valley Historical Museum recreates part of the original Potato Festival held in Perris during the potato harvest in the 1950s through the 1970s. In 2004, this sweet little girl, A. Anderson, is getting her picture taken with Potato Pete and Potato Patty, the mascots the museum uses for this event. One of the things the children enjoy most is dressing up real potatoes with fabric and craft items to create little potato people.

**METROLINK COMES TO PERRIS.** The long-awaited Perris Valley Line for Metrolink has finally arrived in Perris. On December 11, 2015, a grand-opening ceremony was held at the Metrolink site in downtown Perris to great fanfare. Shown here are two trains meeting head-to-head on the track. The past meets the present with the new Metrolink train and a steam engine from the Orange Empire Railway Museum. History has been made once again. (Courtesy of Anthony Le Duff.)

**DROP ZONE WATER PARK.** The grand opening for the Drop Zone Water Park was held on May 24, 2014, with a great celebration. It was a huge effort on the part of dedicated Perris Valley citizen Charlene Busch (center), who worked tirelessly to make this project a reality. Pictured with her is her daughter Holly and husband, Barry Busch. With the help of Riverside County Fifth District supervisor Marion Ashley, Third District supervisor Jeff Stone, the Riverside County Economic Development Agency, and the City of Perris, they made it happen. For her efforts in seeing the project through to completion, the Lazy River at the water park was named in honor of Charlene Busch.

PERRIS CENTENNIAL GALA CELEBRATION. On March 5, 2011, the Perris Valley Chamber of Commerce held its installation dinner in combination with a gala celebrating the city's centennial. The event was held at the historic Perris Theater, where the grounds were covered in a huge elegantly decorated tent. It was an exciting and glamorous affair. They even hired a Marilyn Monroe impersonator. Pictured here with "Marilyn" are Midgie Parker (left) and Deborah Bowman.

CENTENNIAL FASHION SHOW. The Perris Valley Historical Museum sponsored multiple events during the city's centennial celebration in 2011, including this fashion show featuring 100 years of style. The historic Perris Theater hosted the hugely successful event. This photograph shows several children dressed up in 1950s clothing.

CITY OF PERRIS CENTENNIAL EXHIBITION. In 2011, the City of Perris asked the Perris Valley Historical Museum to design and build an exhibit showing 100 years of Perris history. After more than 1,000 hours of volunteer time over several months, 150 history panels measuring seven feet tall and four feet wide were created and exhibited at the Southern California Fairgrounds in the 10,000-square-foot Harrison Hall building in October 2011. This photograph shows the scope of a small portion of this exhibit. The museum received many compliments for its hard work. Volunteer Dave Stuart designed the floor plan, and Dan Yost of PowerFlow Communication created and printed the graphics for the boards.

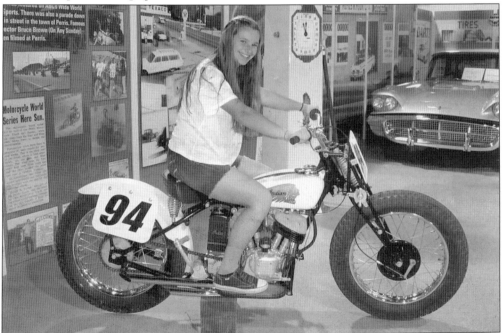

CLOSE-UP VIEW OF CENTENNIAL EXHIBITION. Shown in this photograph is the 1950s and 1960s era of the exhibition. Dan Yost volunteered his father's 1926 Indian Scout motorcycle for the exhibit. Forrest Yost did flat track racing at the Perris Motorcycle Track in the 1950s. Sitting on the motorcycle is Katelyn Loar, the granddaughter of Katie Keyes.

**D Street Documentary Premiere.** Vincent Magana is seen at left among the large crowd attending the premiere of *D Street: A Documentary*. He is from two Perris pioneer families, the Del Rios and Moras. As one of the people featured in the documentary, Magana delighted in bringing his family to the premiere. On the far right is JoAnne Yost, who is meeting Magana's family. The Perris Regency Theater and the Coudures family's Perris Plaza Shopping Center generously donated use of the theater and grounds for the evening. (Courtesy of Dan Yost.)

**Dedicated Volunteer.** Dave Stuart is shown volunteering at the Bob Glass Gym after the D Street documentary premiere dinner. Stuart has a long list of volunteer work for the city of Perris and nonprofit organizations and was named 2016 Volunteer of the Year for the city of Perris by Riverside County Fifth District supervisor Marion Ashley. (Courtesy of Dan Yost.)

D STREET DOCUMENTARY. During the city of Perris's centennial year in 2011, David Ellis Van Houten, the great-grandson of Albert and Mabel Hook, wanted to do a tribute to Perris. Van Houten is a producer of documentaries and owner of BorderLine Hollywood. The Perris Valley Historical Museum helped him arrange interviews, provided him with access to photographs, and kept him apprised of the events. Van Houten and his film crew followed up, and on October 20, 2012, a premiere and dinner was held in Perris. Dan Yost, owner of PowerFlow Communication, designed the graphics for the film, as seen here. (Courtesy of Dan Yost.)

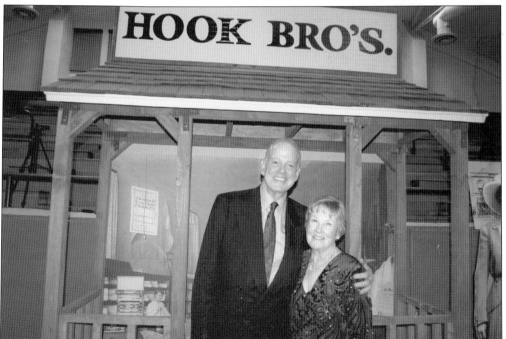

HOOK FAMILY DESCENDANTS. The Hook family has had a presence in Perris since 1888. Rufus M. Hook Jr. remained an important businessman until he passed away in 1983. His wife, Peggy, continued to live in the Hooks' Victorian-era home on Seventh Street and was instrumental in Perris civic affairs. She passed away in 2012. Pictured here are David Ellis Van Houten and Christine Hook Tostenson, the only surviving great-grandchildren of Albert and Mabel Hook. (Courtesy of Dan Yost.)

# Discover Thousands of Local History Books
## Featuring Millions of Vintage Images

Arcadia Publishing, the leading local history publisher in the United States, is committed to making history accessible and meaningful through publishing books that celebrate and preserve the heritage of America's people and places.

Find more books like this at
**www.arcadiapublishing.com**

Search for your hometown history, your old stomping grounds, and even your favorite sports team.

Consistent with our mission to preserve history on a local level, this book was printed in South Carolina on American-made paper and manufactured entirely in the United States. Products carrying the accredited Forest Stewardship Council (FSC) label are printed on 100 percent FSC-certified paper.